Medieval Women

Medieval Women

Michelle Rosenberg

PEN & SWORD
HISTORY

First published in Great Britain in 2024 by
Pen & Sword History
An imprint of Pen & Sword Books Limited
Yorkshire – Philadelphia

ISBN 978 1 52673 148 7

Typeset by Mac Style
Printed in the UK by CPI Group (UK) Ltd, Croydon, CR0 4YY.

Pen & Sword Books Limited incorporates the imprints of After
the Battle, Atlas, Archaeology, Aviation, Discovery, Family History,
Fiction, History, Maritime, Military, Military Classics, Politics,
Select, Transport, True Crime, Air World, Frontline Publishing, Leo
Cooper, Remember When, Seaforth Publishing, The Praetorian Press,
Wharncliffe Local History, Wharncliffe Transport, Wharncliffe True
Crime and White Owl.

For a complete list of Pen & Sword titles please contact

PEN & SWORD BOOKS LIMITED
47 Church Street, Barnsley, South Yorkshire, S70 2AS, England
E-mail: enquiries@pen-and-sword.co.uk
Website: www.pen-and-sword.co.uk
or
PEN AND SWORD BOOKS
1950 Lawrence Rd, Havertown, PA 19083, USA
E-mail: Uspen-and-sword@casematepublishers.com
Website: www.penandswordbooks.com

For Mum, aka 'HRH', who would have made a
brilliant Egyptologist and said:

'Michelle, of course I know who "Berangaria of Navarre" is.'

Contents

Introduction ix

Chapter 1 Theodora (c.497–548) 1

Chapter 2 Æthelflæd (c.870–12 June 918) Lady of the
Mercians 6

Chapter 3 Lady Godiva c.990–10 September 1067
(Old English: Godgifu) 9

Chapter 4 Matilda of Flanders (1051–1083)
Queen of England and Duchess of Normandy 13

Chapter 5 Anna Comnena/Komnene (1/2 December
1083–c.1153) 22

Chapter 6 Morphia/Morfia of Melitene/Melitine
(c. 1075–October 1126) 27

Chapter 7 Heloise d'Argenteuil (c. 1098–19 May 1163) 31

Chapter 8 Melisende, Queen of Jerusalem (1105–1161) 35

Chapter 9 Melisende's Sisters: Alice of Antioch
(c.1110–after 1136) 42

Chapter 10 Hodierna of Jerusalem (c.1110–1164) 44

Chapter 11 Joveta/Ioveta of Bethany (c.1120 – between 1161
and 1178) 46

Chapter 12 Eleanor of Aquitaine (1122–1204) 48

Chapter 13 Rosamund de Clifford (c.1140–c.1176)
 aka 'Fair Rosamund' 53

Chapter 14 Margaret of Beverley (Margaret of Jerusalem)
 (1150–1214) 56

Chapter 15 Sibylla of Jerusalem (1160–1190) 59

Chapter 16 Berengaria of Navarre (1165–1230) 65

Chapter 17 Licoricia of Winchester (early thirteenth
 century – 1277) 71

Chapter 18 Philippa of Hainault (1314–15 August 1369) 74

Chapter 19 Julian of Norwich (1342–c.1416) 79

Chapter 20 Alice Perrers, aka Alice de Windsor (1348–1400) 83

Chapter 21 Katherine Swynford, Duchess of Lancaster
 (c.1350–10 May 1403) 87

Chapter 22 Christine de Pizan (1364–c. 1430) 93

Chapter 23 Margery Kempe (c.1373 – after 1438) 101

Chapter 24 Joan of Arc (1412–1431) 105

Chapter 25 Isabella of Castile (22 April 1451–26 November
 1504) 108

Chapter 26 Anne Neville (11 June 1456–16 March 1485) 113

Chapter 27 Lucrezia Borgia (18 April 1480–24 June 1519) 117

Chapter 28 Dona Gracia Mendes (1510–1569) 122

Notes 129

Introduction

The medieval period of European history lies between the fall of the Roman Empire in AD 476 and the beginning of the Renaissance in the fourteenth or fifteenth century (depending on which area of Europe). It is sometimes referred to as the 'Dark Ages', because after the fall of Rome, no one was recording their own history in the way the Romans had.

The period witnessed the Black Death, or bubonic plague, between 1347 and 1350, which decimated 20 million people across Europe, 30 per cent of its entire population. The Catholic church was incredibly powerful, with ordinary people tithing 10 per cent of their earnings every year, while the rise of Islam saw Muslim armies seizing large parts of the Middle East. At its peak, the medieval Islamic world was over three times larger than the whole of Christendom.

Accordingly, the Christian world decided to fight back against the 'infidel', authorising military expeditions or Crusades from 1095 to expel Muslims from the Holy Land. They would continue intermittently until the end of the fifteenth century.

It was also a period of castle building (with William the Conqueror responsible for a huge expansion in building works to protect his newly conquered lands); between 1066 and 1087, William and the Normans built nearly 700 across England and Wales. The Domesday Book of 1086 reveals that 74 per cent of the population of the English countryside were slaves to serfdom. This lower hierarchy were bound to a life of servitude, their every life change decided upon by their lord, including marriage.[1]

The medieval era plays host to a number of key characters, including Charlemagne, Joan of Arc, William the Conqueror, Eleanor of Aquitaine, Richard the Lionheart, William Wallace, Geoffrey Chaucer and Vlad the Impaler.

The following timeline gives an idea of the scope of the period and the events that took place, and puts the women featured in this book into their historical context:

476: The fall of the Roman Empire.

481: Clovis becomes King of the Franks and unites most of the Frankish tribes that were part of the Roman Province of Gaul.

570: Muhammad, prophet of Islam is born.

732: Battle of Tours. The Franks defeat the Muslims, turning back Islam from Europe.

800: Charlemagne, King of the Franks, is crowned Holy Roman Emperor.

835: Vikings from the Scandinavian lands (Denmark, Norway, and Sweden) invade northern Europe and continue to do so until 1042.

896: Alfred the Great, King of England, turns back the Viking invaders.

1066: French Duke, William of Normandy conquers England in the Battle of Hastings and becomes King of England.

1096: The First Crusade.

1189: Richard I, (Richard the Lionheart), becomes King of England.

1206: Genghis Khan founds The Mongol Empire.

1215: King John of England signs the Magna Carta.

1271: Marco Polo leaves on his famous journey to explore Asia.

1337: The Hundred Years War begins between England and France for control of the French throne.

1347: The Black Death begins.

1431: Joan of Arc is executed by England at the age of 19.

1444: German Johannes Gutenberg invents the printing press, marking the start of the Renaissance.

1453: The Ottoman Empire captures Constantinople. This represents the end of the Eastern Roman Empire also known as Byzantium.

1482: Leonardo Da Vinci paints 'The Last Supper'.

Women in the Middle Ages were frequently characterised as second-class citizens by the Church and the patriarchal aristocracy. Their status was somewhat elevated in the High and Late Middle Ages when the cult of the Virgin Mary, combined with the romantic literature of courtly love, altered the cultural perception of women but even so, women were still considered inferior to men owing to biblical narratives and the teachings of the Church.[2]

Women's lives generally were characterised by back-breaking manual labour and obedience to the church and men in their lives. Fires to cook dinner did not, alas, light themselves and the medieval version of washing detergent, 'lye' had to be made before any linens or clothes could be soaked.[3]

Subordinate to both men and the church, generally their prospects were poor, largely limited to being a deferential, compliant domestic wife and mother. A feudal system of government divided society into three classes: clergy, nobility, and serfs.

From the fifth century onwards, Christian convents allowed women to forge an alternative path to matrimony: to join them, become educated and literate and devote themselves to a religious life of contemplation and service. Rising to the ranks of an abbess (the head of an abbey of nuns) would make them powerful individuals; they would govern their convent and manage its lands.

Women of noble birth were ranked by how much property – and thus power – they brought to a marriage. Married women were not allowed to inherit family property; they could be promised in marriage at the age of 5, although wouldn't be wed until they were 12 or 14.

Many women from the Middle Ages could neither read nor write while 90 per cent of the Western European population lived in the countryside or small towns. Women of the lower classes would work alongside the men in the fields; theirs would be a tough and work-intensive life, responsible for churning butter, brewing ale, looking after livestock, spinning and weaving cloth to make clothes for the family. The most common symbol of a medieval peasant woman was a distaff, used for spinning flax and wool. Disobedient women were often beaten into submission; a woman would first have to submit to their father; after marriage, to her husband. To even get married in the first place, they had to secure the agreement and permission of their parents; additionally, they were forbidden to own a business without similar permission, nor divorce their husbands, own their own property only if they were widows, couldn't inherit land from their parents and had no brothers who would supercede their claim.[4]

Demonstrating that the glass ceiling for women was alive and well 'way back when', it's estimated that while working the land, women would earn less than men. Medieval documents reveal that for reaping in a field, a man would earn 8 pence per day; for the same job, a woman would receive 5 pence; for hay making, men earned 6 pence to a woman's 4 pence for the same work.[5]

Additionally, in many towns, women were largely barred from joining medieval trade guilds; married women were not allowed to sign contracts, act as a witness in court or borrow money in their own name. Everything had to be done under the authority of their husband. Single women in the medieval period were known as unmarried, unwed, spinster, husbandless or maiden.

Life expectancy for women was around 33 years old. They and their families faced diseases like smallpox, dysentery, influenza, childbirth, sweating sickness, typhoid, famine, war, malnutrition and tuberculosis. Wealth and fortune would not provide you with immunity from illness – it's estimated that between 1330 and 1479, one third of children born into aristocratic or ducal families, perished before reaching their fifth birthday. Breech birth would often prove fatal to both mother and child.

Most of the medieval world rarely saw a legitimate physician. Instead, they relied on the local wise-woman and her knowledge of herbs and tinctures, mothers, and midwives. It was the wise woman who would likely deliver a baby; nuns also ran hospitals and took in the sick and dying.

Women were largely excluded from professional medical and academic institutions. This meant that they inhabited the sphere of 'herbalists, midwives, surgeons, barber-surgeons, nurses, and empirics, the traditional healers. Untutored in medicine, they used therapies based on botanicals, traditional home remedies, purges, bloodletting, and native intelligence. Their medications were compounded of plant materials, some superstition, and a dash of charlatanism.'[6]

Medieval medicine was based on the Greek traditions founded by Hippocrates, with the body made up of four humours: yellow bile, phlegm, black bile and blood, all controlled by the four elements of earth, air, fire and water. Therapies working alongside these, to purge the body of excess in any of the humours, included cupping, leeching and bleeding.

With regards to herbal medicine, in rural parts of England, like the Fenlands, treatments were part of the ancient culture. Cures and remedies were passed down from mother to daughter and shared between certain women in the community. For a long time, the

human body was not understood scientifically so many wise women turned to magic, charms and spells.

For example, the medieval herbal remedy to cure headaches and joint pain instructed a practitioner to:

- Take equal amounts of radish, bishopwort, garlic, wormwood, helenium, cropleek and hollowleek.
- Pound them up and boil them in butter with celandine and red nettle.
- Keep the mixture in a brass pot until it is a dark red colour.
- Strain it through a cloth and smear on the forehead or aching joints.[7]

'Women have always been healers. They were the unlicensed doctors and anatomists of western history. They were abortionists, nurses and counsellors. They were pharmacists, cultivating healing herbs and exchanging the secrets of their uses. They were midwives, travelling from home to home and village to village. For centuries women were doctors without degrees, barred from books and lectures, learning from each other, and passing on experience from neighbor to neighbor and mother to daughter. They were called 'wise women' by the people, witches, or charlatans by the authorities. Medicine is part of our heritage as women, our history, our birthright.'[8]

These female healers would, in the latter stages of the Middle Ages, be subject to accusations of witchcraft; their knowledge of herbal medicine used against them, seen as unnatural and a challenge to the natural order of the church-led patriarchy. Wise women who practiced folk medicine and midwifery were natural targets of suspicion: often spinsters or widows, peasants who needed to work for a living, lady loners side-lined by society, but

they played an important cultural role. Indeed, between 1400 and 1700, more than 100,000 women were burnt at the stake for witchcraft.

The medieval women whose stories we do know have been recorded either because their lives pleased the church, or because in the eyes of male historians, they were scandalous enough, or worthy enough of praise, to warrant being remembered. Those who were deemed scandalous defied societal norms and lived a life on their own terms – much like a man. Most of the women profiled here are from the upper classes or nobility – they had the means to be different.

This book presents a small window into the women of the Middle Ages, presenting mystics, mistresses, queens of conquerors, rulers, early feminists, the author of the first autobiography in English, and the woman who famously rode naked through Coventry.

Anglo-Saxon queen Æthelflæd personally led armies into direct combat with Vikings in the 900s, saving England from foreign invasion. Byzantine Empress Theodora kept the empire from falling apart during the Nika Revolts and stopped her husband Justinian from fleeing Constantinople. The ship on which William the Conqueror sailed to England was a gift from his wife Matilda; Alice of Antioch launched no less than three failed coups in her determination to have her own place on the throne while Margaret of Beverley is likely to have been the first woman crusader to have experienced direct military action when she fought the Saracens in Jerusalem.

As ever, this book sheds light on a tiny minority of women's stories; their lives deemed important enough to have been recorded. How many more must be unknown, buried and lost forever – and we are the poorer for it.

Leaving this introduction on a more positive, and sweeter note on which to feast your senses as well as your mind, I leave you with

two medieval recipes: the first for a rose dessert, courtesy of the British Museum, which I hope helps to further set the scene, if not the pudding, together with instructions for medieval mulled wine, to wash it all down.

Rose pudding (vegetarian)

Take thyk milke; sethe it. Cast therto sugur, a gode porcioun; pynes, dates ymynced, canel, & powdour gynger; and seeth it, and alye it with flours of white rosis, and flour of rys. Cole it; salt it & messe it forth. If thou wilt in stede of almounde mylke, take swete crem of kyne.

Ingredients

Petals of one white rose
4 level tbsp rice flour or cornflour
275ml milk
50g caster sugar
3/4 tsp ground cinnamon
3/4 tsp ground ginger
575ml single cream
Pinch of salt
10 dessert dates stoned and finely chopped
1 tbsp chopped pine nut kernels

Method

Take the petals off the rose one by one. Blanch the petals in boiling water for 2 minutes, then press them between several sheets of soft kitchen paper and put a heavy flat weight on top to squeeze them dry. (They may look depressingly greyish, but blending will improve the dish's colour.) Put the rice flour or cornflour in a saucepan, and blend into it enough of the milk to make a smooth cream. Stir in

the remaining milk. Place the pan over low heat and stir until the mixture starts to thicken. Put in a (non-medieval!) electric blender, and add the sugar, spices and rose petals. Process until fully blended, then add and blend in the cream and salt. Turn the mixture into a heavy saucepan, and stir over very low heat, below the boil, until it is the consistency of softly whipped cream. Stir in most of the chopped dates and pine nut kernels and stir for 2 more minutes. Turn into a glass or decorative bowl and cool. Stir occasionally while cooling to prevent a skin forming. Chill. Just before serving decorate with the remaining dates and nuts.

Piment or medieval mulled wine (vegan)

Pur fait ypocras. Troys vnces de canell & iii vnces gyngeuer; spykenard de Spayn, le pays dun denerer; garyngale, clowes gylofre, poeure long, noiey mugadey, mayioyame, cardemonii, de chescun i quarter donce; grayne de paradys, flour de queynel, de chescun dm. vnce; de tout soit fait powdour &c.

Piment was the general name for sweetened spiced wines in the Middle Ages. The first recipes for spiced wine appeared at the end of the thirteenth century and the beginning of the fourteenth century. The recipe above is for *Hypocras*, another type of spiced wine but it contains long pepper (*poeure long*), the grains of paradise (*grayne de paradis*), spikenard (*spykenard*), which are very hard to get hold of today.

The drink became extremely popular and was regarded as having various medicinal or even aphrodisiac properties. Spices were among the most luxurious products available in the Middle Ages.

Ingredients

2 ltr red wine (check the label to ensure that ingredients are vegan if you want to make this recipe vegan)

175g white sugar

1 tbsp ground cinnamon

1/4 tbsp ground ginger

1 tsp each ground cloves, grated nutmeg, marjoram (fresh if possible), ground cardamom, ground black pepper and a pinch of grated galingale (if available)

Method

Warm the wine until it just begins to steam. Add the sugar and allow to dissolve. Mix all the spices and herbs together. Stir half this mixture into the wine, then taste and slowly add more until you achieve a flavour you like (you will probably need most, or all, of the mixture). Simmer your 'mix' very gently for 10 minutes. Strain through a jelly bag (which may take some hours). Bottle when cold, then cork securely. Use within a week.[9]

Chapter 1

Theodora (c.497–548)

Let's set the scene: deciding that the entire Roman Empire was too huge to manage effectively, (covering Europe, north Africa and parts of Asia, it could take weeks for a message from Rome to reach its destination), Emperor Diocletian made the decision in AD 285 to split it into two halves: the western half would be based out of Rome and the eastern in Byzantium.

When Emperor Constantine I came to power in AD 306, he renamed Byzantium 'Constantinople'. Most of the Byzantines had Greek origins, but it was hugely diverse, including Armenians, Jews, Syrians, Italians, Arabs, Persians and Georgians. It clung to its Roman roots, with Byzantines referring to themselves as 'Romaioi' or Romans, and they continued to follow Roman laws, customs, and games. It was the Byzantine Empire, which wasn't given its name until after it fell to the Turks in 1453, that is regarded as bridging the gap between the Classical and Renaissance worlds.

It was Emperor Constantine who laid the foundations for the early Byzantine Empire, when in 324 he left Rome behind to transport his court to Byzantium, then an ancient port town on the Bosporus Strait. It took just six years for Constantine to transform the Greek colony into a teaming metropolis, which in 330 he dedicated as 'Nova Roma' or 'New Rome', although it soon became known as 'Constantinople' in deference to its architect.

Byzantine Empress Theodora of Constantinople (today's Istanbul) came from humble beginnings. We don't know her exact birth date,

not unusual for the time – and especially for women. She was born less than a century after the death of Hypatia, one of the last great philosophers of Alexandria and one of the first women to study and teach astronomy and mathematics.

Her father Acacius was a poor bear keeper at Constantinople's entertainment and racing centre and circus, the Hippodrome; we know nothing of her mother, other than she was a dancer and actress.

Their family had some political connection, being part of the working-class 'Green' faction, who supported the corresponding 'Green' Hippodrome chariot-racing team. Their rivals were the 'Blue' team, who had higher social status and standing.

Theodora was 5 years old when her father died – and the family's situation became desperate. Her mother remarried quickly to stabilise their situation; she tried and failed to gain the Greens' support in securing her new husband a job. Theodora's mother encouraged her three daughters to supplicate themselves before the Greens, but they mocked and dismissed her. It was the Blues who would seize a political advantage and offer her husband a job as bear keeper. In doing so, they secured Theodora's enduring loyalty and support.

It's likely that Theodora and her two sisters, Comito and Anastasia, worked in a brothel. We know Theodora worked as an actress from the age of 12, alongside her older sister Comito; she was also a dancer, mime artist and comedian. As an 'actress', it wouldn't have been unusual for her to work as a courtesan – to put it bluntly, she was a child prostitute, and by the age of 14 she had a daughter. By 15, she was the star of the Hippodrome; it's more than likely that she and Comito had several abortions.

It's doubtful that she was the depraved sexual monster portrayed by her biographer, the sixth-century Byzantine historian Procopius of Caesarea in his book *The Secret History*, written after her death (although not published until the seventeenth century). Indeed, much

of his lurid details about Theodora's early years as a low-rent whore, (he referred to her as 'Theodora-from-the-Brothel') probably owe more to his own lewd imagination than to actual fact, including one example of a night spent with thirty men and some geese. According to Procopius, she also allegedly regretted she had but three orifices for sexual pleasure.

At the age of 16 she travelled to North Africa with Hecebolus, a Syrian official and governor, as his mistress, as he acted as governor of what is Libya today. He didn't treat her well, but she stayed with him for around four years before he eventually abandoned her. With her young daughter, she moved to Alexandria and then Antioch (a city in Syria). In the midst of an ascetic desert community, she was converted to miaphysitism, a nonorthodox doctrine and early form of Christianity. It believed that Jesus Christ was an entirely divine being; this was regarded as heretical by Rome, which was pro-orthodoxy and of the belief that Christ was both mortal and divine.

It was in the desert that she met Macedonia, a dancer, member of the Blues and likely spy. It was this friendship that enabled Theodora to return to Constantinople, (also known as the Queen of Cities, Istinpolin, Stamboul and eventually today's Istanbul) and secure a job as a wool spinner. From AD 330 until 1453, when it was taken by Ottoman Sultan Mehmed II (known as 'The Conqueror'), the city was the centre of the Byzantine world.

It was there, and with an introduction made by Macedonia, that she caught the besotted attention of Justinian, farmer's son from what is now Serbia, heir to the throne of his uncle, Emperor Justin I, and twenty years her senior. He made her his mistress and determined to change the law prohibiting actresses to marry anyone of a senatorial rank. He eventually succeeded, thus allowing 'truly repentant' actresses to marry those of a higher rank – directly against the wishes of Justinian's aunt, the Empress Euphemia, who herself had been a

prostitute, and according to Procopius, likely a slave and barbarian before marrying an emperor. By this time, the couple already had a daughter, and when Justinian was made emperor in 527, Theodora was made 'augusta': Empress of Rome.

A true power couple, she was his closest advisor. Sources show the extent of her influence – with her name on nearly all of the law passed during the period. It's known that she had a key diplomatic role, meeting, receiving and corresponding with foreign envoys and their rulers – actions which would have normally been reserved for the emperor himself. Her personal stamp of authority was also demonstrated during the Nika revolt of January 532, The Blues, and the Greens, the two main political camps in Constantinople, teamed up against the government to establish a rival emperor. While Justininan's advisors told him to run for his life, it was Theodora who counselled him to stay and fight for his Empire. He took her advice and directed his general Belisarius to take decisive and ruthless action; the rioters were herded like lambs to the slaughter into the Hippodrome and cut down.

Thirty thousand people were killed in the ongoing massacre – an estimated one tenth of the entire population of Constantinople. In urging her less courageous husband not to flee, Theodora told him: 'If you wish to save yourself, my lord, there is no difficulty. As for me, I agree with the saying that royal purple is the noblest shroud.' She insisted that the head of the rebellion was executed.

Her radical reforms included laws to protect women at risk, such as her former friends engaged in prostitution, and making rape punishable by death. She also built a convent, gave women rights in divorce, and banned forced prostitution; because of her actions and laws, brothel-keepers were banned from Constantinople and in other major cities across the empire. Stella Duffy, who has written a superb historical fiction novel about Theodora, suggests we don't paint her as a saint just yet:

There are hints that she was involved in poisoning, torture and forced marriage, and while she did a great deal to help women and girls in difficulty, she had rather less time for women of higher standing – attacking any who threatened her position, including the empress Euphemia.[1]

She insisted on protection for her fellow Monophysites within the palace, even though her husband was Orthodox. During her reign, the stunning Hagia Sophia domed church was rebuilt; regarded as an architectural wonder of the world, it still stands as a superb example of Byzantine architecture and craftsmanship.

Theodora died of a 'cancer' or gangrene on 28 June 548 at the age of 48 and is buried in the church of the Holy Apostles in Constantinople.

Chapter 2

Æthelflæd (c.870 – 12 June 918)
Lady of the Mercians

1 2 June 2018 marked the 1,100-year anniversary of a Saxon warrior, Æthelflæd, Lady of the Mercians and eldest daughter of Alfred the Great, king of the Anglo-Saxon kingdom of Wessex. Nothing is known of Æthelflæd until records show her marriage at the age of 15 or 16. Her mother was Ealhswith, a Mercian noblewoman, while her father, Alfred, was descended from Wessex royalty.

Alfred spent considerable time fighting off the Vikings, who in AD 793 sacked the priory of Lindisfarne, just off the Northumbrian coast in northern England. Æthelflæd was born at an extremely tense time; on 6 January 878, when she was around 8 years old, a surprise attack by the Vikings, led by King Guthrum, came perilously close to capturing Alfred and his family at their winter fortress at Chippenham. They had to run for their lives and spent four months hiding in the marshes of Somerset. This is where the legend of the 'burnt cakes' comes from; Alfred and his men were hiding in the swamps of Somerset, living a hand-to-mouth existence and largely dependent on the largesse of the locals for food and shelter. The story says that he took refuge with a peasant woman, who asked him to watch over his 'cakes', or small loaves of bread, which were baking by the fire. Wholly distracted by the imminent dangers around him, Alfred neglected – and burnt – the cakes.

Months later, with an army of around 3,000 men from Somerset, Wiltshire and West Hampshire, Alfred roundly defeated Guthrum

and his Viking army at the Battle of Edington. Following their surrender, Guthrum and thirty of his surviving soldiers were baptised on 15 June, 878; Alfred stood as Guthrum's godfather. By 886, according to the *Anglo-Saxon Chronicle*, 'All the English peoples acknowledged Alfred as their king except those who were still under the rule of the Danes in the North and the East.'

Educated and cultured, Æthelflæd was married at just 16 to Aethelred, Lord of Mercia; he was at least ten years her senior. The marriage would strengthen a pre-existing alliance between Mercia and Wessex, and they were apparently ambushed by Vikings en route to their wedding in an attempt to stop the union; several of her party were killed before they were able to reach the safety of a ditch and fight back.

Æthelflæd and Aethelred had one daughter, Aelfwynn, first named on a land charter in AD 903. According to the monk and renowned twelfth-century historian William of Malmsbury, (c.1095 – c.1143) the birth was so traumatic that it nearly killed Æthelflæd and left her unable to have any more children. When her father Alfred died in 899, her younger brother, Edward, became king. Together, the siblings would work to drive the Vikings out of Britain.

Having learned from her mother, she was an able leader, skilled negotiator and military tactician, earning the respect of both the Vikings and the Saxons. She personally led campaigns against the Vikings with her husband in the Midlands and the north. Following his death in 911, Æthelflæd became queen of Mercia.

Ever aware of the threat of Viking attacks, Æthelflæd fortified former Roman strongholds and built fortified towns. She reconstructed Gloucester from its Roman ruins and laid out its street plan, which still exists today. She also won back lands that had been lost to the Danes, including Derby and Leicester. As well as Gloucester, she either rebuilt or founded the county towns of Hereford, Worcester,

Chester, Shrewsbury, Warwick, and Stafford. (Details of events in Mercia between 904 and 924 are found in the Mercian Register, part of the *Anglo-Saxon Chronicle*, three copies of which are held at the British Library).

The city of Chester was, at that time, a key trading point for Mercia with Ireland; it was also on the trading route between Viking York and the port of Dublin. When the Irish drove the Danes out, some crossed the sea and settled just outside Chester, with a promise that they would behave. They were unable to keep to their promise of not attacking the town and Æthelflæd defeated them in the violent Battle of Chester in AD 907. She subsequently strove to unite England.

Edward's son, and her nephew, Athelstan, became king of the Anglo Saxons and the first king of England on 4 September, 925 and reigned between until 939. He is buried in Malmesbury Abbey.

She died at Tamworth (of reasons unknown) in 918, just as the Danes in York were on the brink of surrendering their stronghold to her. She was buried at what is now St Oswald's Priory in Gloucester. Her daughter was accepted as her successor in an uncontested transference of power – unheard of then – and not again until the English throne passed from Mary I to Elizabeth I in 1558.

Chapter 3

Lady Godiva c.990 – 10 September 1067
(Old English: Godgifu)

Religious, philanthropic, and wealthy, this eleventh-century noblewoman, Godiva (Godifu, Godgifu, meaning 'Gift of God', or Godgyfu) Countess of Mercia, has captured history's imagination to become something of a feminist icon, artistic sex symbol and early female activist.

Although it is unclear who her parents were, Godiva held lands in her own right in Coventry, Warwickshire, Ansty and Madeley. Her name is mentioned in the history of Ely Abbey (on the island of Ely in Cambridgeshire); the twelfth-century English chronicle and history, made up of three volumes, *Liber Eliensis* (sometimes *Historia Eliensis* or *Book of Ely*) states that Godiva was a widow before she married Leofric, made Earl of Mercia by King Cnut.

According to legend, Godiva rode naked on a horse through Coventry marketplace to demonstrate her frustration at Leofric over oppressively high taxes levied on his tenants, who would starve if they were forced to pay. The deal was that if Godiva dared to ride naked, he would lower the taxes. Her condition was that the locals had to stay inside their houses with the windows closed.

She covered herself with her long hair and clambered up on the horse. Once she'd completed the dare, Leofric pledged to free Coventry from taxes, and apparently underwent a religious conversion.

The *Liber* notes Godiva and Leofric's generosity as benefactors to various monasteries, stating that they gave so many jewels and holy

relics to the monastery in Coventry that 'the very walls seemed too narrow for all this treasure'.[1]

As well as the Anglo Saxon Earl of Mercia, Leofric was also Lord of Coventry and known as the Earl of Chester, because he spent time there. He was one of the most powerful noblemen in the country at the time. Godiva, however, would not have had the title 'Lady', as that was reserved for the queen. She was likely referred to as 'the earl's wife', or 'the earl's bed-partner'.

Together they founded a Benedictine monastery in Coventry. She is depicted in a stained-glass window in a church in Hereford. As one of the three great earls of the eleventh century, historical sources are mixed when referring to Leofric's character; some describe him as a tyrant, while others depict him as politically shrewd and a generous supporter of the church.

The story first came to light via Roger Wendover, a monk of St Albans' Abbey in the late 1100s, writing in the *Flores Historiarum* over a century after Godiva's death. His account should be taken with a pinch of salt as historians have long suspected he exaggerated his tales to make them more appealing. In his defence, however, just because Wenover was the first writer of the legend shouldn't detract from the fact that it was likely passed down through oral tradition. It's also suggested that too many parts of the story are enough to make them unlikely to have been fake or imagined. Another theory as to how Wendover first heard the story is offered by sixteenth-century chronicler Richard Grafton. He believes that it was recorded in a chronicle, now lost to history, but shown to Wendover by the monastic superior of Coventry Monastery between 1216 and 1235. Sometime in the sixteenth century, the details of the Peeping Tom were added. This version describes Godiva advising the townsfolk to stay indoors and close their windows to preserve her modesty. A tailor named Tom, however, was too curious to obey the order and

came out to watch the glorious spectacle of a naked Lady Godiva; as punishment from God, he was blinded for his impudence.

The myth of Lady Godiva was later popularised by was Alfred Lord Tennyson, who in his 1842 eponymous poem, written as he waited for a train in Coventry. Lady Godiva's story has been adapted over time and shaped according to various periods of great change in women's freedoms. During the Middle Ages, it was a story steeped in an age of romance, chivalry and courtly love and likely swept through the female dominated courts of Eleanor of Aquitaine, giving rise to the idea of it being one of the earliest expressions of feminism.

Critic and novelist Robert Graves believes 'the medieval romancing of the Godiva story demonstrates this … as the medieval Godiva 'cult' … Godiva reflected more than a woman or a saint – she was a medieval manifestation of the pagan Goddess, re- or rather, un-clad.'[2]

The Herbert Art Gallery in Coventry has a dedicated and permanent collection of artworks devoted to Lady Godiva; it includes a painting dating back to the sixteenth century. The gallery refers to Godiva as 'a symbol of Coventry, protest and female empowerment'. Most of the images are very romanticised, likely bearing little resemblance to either what she, or Coventry, looked like at the time. The oldest known painting of Godiva was commissioned by Coventry Corporation in 1586.

Lady Godiva is buried at St Mary's Priory and Cathedral. She is mentioned in the Domesday Book (the famous Norman survey of English property, ordered by William the Conqueror) – as 'Godeva', one of the very few women to be afforded the honour because she was unique enough in owning land in her own right. It says she survived her husband's death in 1057 and is still mentioned in it as a major landowner after the Normal Conquest in 1066. She probably died between 1066 and 1086.

The Annual Coventry Fair retold Lady Godiva's story – until it was banned during the Reformation, only to be revived in 1678. The city has most recently had an 'official' Lady Godiva (Pru Poretta, MBE) who has re-enacted the famous horse ride in the historic Godiva Procession. In 2016, Coventry celebrated 1,000 years since the convent of St Osburgs was destroyed by the Danes.

Chapter 4

Matilda of Flanders (1051–1083) Queen of England and Duchess of Normandy

She was even more distinguished for the purity of her mind and manners than for her illustrious lineage… She united beauty with gentle breeding and all the graces of Christian holiness.
The Anglo-Norman chronicler, Orderic Vitalis (1075–1142)

William the Conqueror, the Battle of Hastings and 1066; we are all familiar with that historical triple threat. And that's without throwing in the Domesday Book or the New Forest, which William created in around 1079 for royal hunting. The person many people aren't familiar with is his wife, Matilda of Flanders, known as the First queen of England. She was a trusted equal, more than just a royal consort.

The Guinness Book of Records erroneously recorded her as England's smallest queen at just 4ft 2in; however, a scientific exhumation of her remains in 1959 proved she was around 5ft tall.

Taking a few steps back to set the scene: William the Conqueror, (William I, or William the Bastard), was the illegitimate son of Robert I, Duke of Normandy, and a mistress known as Herleva, who was the daughter of Filbert from Falaise in Normandy. History assumes he was either a tanner (converting animal pelts or hide into leather) or an embalmer/undertaker.

Variations of Herleva's name include Arletta, Arlette, Arlotta, Arlotte, Erleve, Harlena, Harlette, Herlette, Herleva, Herleve, and Herlotte. Born in 1010, she is the little-known matriarch of a lengthy royal line spanning hundreds of years. Legend has it that Robert was walking along his castle in Falaise and spotted a beautiful young woman washing clothes or animal skins and instructed that she be brought to him.

The beautiful woman, Herleva, had had her first illegitimate child at the age of 16, with the father being Gilbert, Count of Brionne, a powerful landowner. A year later, she became Robert's mistress and gave birth to the future William the Conqueror (then William, Duke of Normandy) in 1028. The birth was traumatic, and she nearly died. Her father was later made a chamberlain to Robert.

There are stories by historian Oderic Vitalis that a furious William took vengeance on the people of Alencon in France who mocked his lowly birth by deliberately hanging animal furs and pelts around their town; he ordered that the hands and feet of the perpetrators be chopped off, while he watched. As Alison Weir points out,

> William's attitude to sexual morality was probably a reaction to his own bastardy, which he found deeply shameful, as his violent treatment of those who taunted him with it makes clear. While defiantly signing his letters 'William Bastard', the Duke would not suffer anyone to remind of his base birth.[1]

Sometime after the birth of William, thought to be around 1031, Robert married Herleva off to his friend Herluin, Victomte of Conteville. (She would go on to have three children with him: Odo, Robert and Muriel). Odo, probably born around 1036 would go on to become an important player in William's life history. He became Bishop of Bayeux and was also a soldier who accompanied William

to England and fought at the Battle of Hastings. It's thought that he may have commissioned the Bayeux Tapestry. In 1067 he was made Earl of Kent, becoming the largest landowner in England, second only to the king himself. Perhaps the grandeur went to his head, because he decided to back William's own son, Robert Curthose, against him. A troublemaker to the end, Odo would be imprisoned and eventually die en route to Palermo as part of the First Crusade in 1097.

Conversely, it was Herleva's other son by Herluin, Robert Count of Mortain, who was one of William's greatest supporters. He provided the Conqueror with ships during the English invasion and was rewarded with huge swathes of land. Herleva is believed to have had at least one daughter, unsurprisingly her life story is mostly lost to history apart from her marriage to William, lord of the La Ferte-Mace.

Herleva's life and legacy would change the course of European history; she likely died around 1050.

When Robert I died, William was his only living son – and although illegitimate, he inherited his father's title. As Duke of Normandy, he ruled the most powerful duchy in western Christendom and was a dependent, or feudal vassal, of the king of France.

With Gilbert, Count of Brionne as his guardian, William had to fight a number of Norman barons who violently refuted his birth right. An attempt was made on his life in 1040; the barons failed, but Gilbert died. William would soon be urged to take a wife.

Enter Matilda. Likely born in 1032 and connected to most of the ruling houses of Europe. Her father was Count Baldwin V of Flanders (modern-day north Belgium) and her mother Adele of France, the youngest daughter of the king of France. Adele was highly educated and ensured her children were too.

Matilda grew up at the court of her father, centred around Bruges. While she wasn't taught to write (the offspring of the ruling classes had

clerics for that), she would have learned to read in Latin, household management, needlework, the Scriptures, and lives of the saints.

While no image of her survives, Anglo-Norman chronicler Orderic Vitalis said she was an individual who possessed, 'beauty of person, high birth, a cultivated mind and exalted virtue.'[2]

Matilda's heritage was impeccable; chronicler William of Poitiers, Archdeacon of Lisieux wrote: 'Her wise and blessed mother [Adela] had nurtured in her daughter a lineage many times greater even than her parent's inheritance.'[3]

No doubt then, that William 'the Bastard' favoured her as his choice to quell gossip about his own birth right and illegitimacy. It was also a desirable choice for Matilda's father; marital links with Normandy would bring Flanders under greater protection from France. Matilda, however, initially had other ideas.

When she was between 15 and 18, she fell in love with Brihtric Mau, a rich Anglo-Saxon landowner sent to Flanders as an ambassador by King Edward the Confessor of England. According to legend, secretly she sent him a message asking him to marry her. He refused – but the scandal could have had disastrous repercussions for her reputation.

The marital alliance didn't have an auspicious start, with William undertaking a 'rough wooing'. He wanted to marry her – but because he was a bastard, descended from Viking raiders and nowhere near her social sphere, she refused him. (Bear in mind that through her father Count Baldwin V of Flanders, she was descended from the Emperor Charlemagne and England's King Alfred the Great. He was also the husband to the sister of the king of France).

In a fit of pique, the legend goes that William dragged Matilda as she left Mass and violently beat her, either in the streets of Bruges, or in the courtyard of her father's castle in Lille, for daring to turn him down. It's also possible that William, at 5ft 10in (5in taller than the average man at the time), red-haired and well built, raped her.

According to Alison Weir, William was so angry that Matilda had refused his offer of marriage that 'He knocked her to the ground and beat her and rolled her' as she returned from Mass. With Matilda still recovering from the attack and her virtue compromised, her father prepared to revenge her honour when she suddenly said: '[William] must be a man of high courage and daring and I want to marry him.'[4]

Pope Leo IX was against the match because of the law of consanguinity (Matilda and William were thought to be first cousins, once removed, related within seven generations – too close for comfort for the church). Despite this opposition, they were married in the winter of either 1049 or 1050. Matilda travelled over 150 miles to reach the county of Eu, on Normandy's eastern border, where the marriage took place at the Church of Notre Dame. The table for the wedding feast would have been set with a cloth and guests offered wine goblets decorated with a cross. Fish and meat would have been served, with each plate of food being shared between two people. Entertainment was provided by troubadours, minstrels and jongleurs or mummers. Important and particularly valued guests would have been seated with the new couple at the 'top' table. According to historian Alison Weir, each attendee would have brought their own knife for use at the meal, to cut food which they'd then eat with their fingers. The guests would ceremonially put the bride and groom to bed before the priest blessed them. Everyone would then leave, rather obviously leaving the newlyweds to cement their union and do their duty.

Also in attendance at the wedding were William's mother Herleva, and his stepfather Herluin. Following the ceremony, Matilda, probably around 19 years old and now the Duchess of the Normans, was escorted by her new husband to his tenth-century chateau at Rouen. The wedding clothes of the bride and groom are described in a 1476 inventory of Bayeux Cathedral. Their two cloaks were

of 'incomparable richness', with Matilda wearing 'a rich, cope-like mantle embroidered with jewels and precious stones'. William's cloak was 'adorned with golden crosses, flowers, intaglios, gems and rich embroidery'. He also wore a helmet, which is preserved at Bayeux.[5]

Unusual for the age, it is said that the couple were faithful to each other. Matilda gave William at least nine children. The eldest was Robert, followed by Richard, William (nicknamed Rufus because of his red hair, complexion, and equally fiery nature, and said to be his father's favourite child), Constance, Adela, Matilda and Adeliza. There may have been as many as six daughters, including a Cecilia and an Agatha.

It appears the marriage was a happy one. As a royal partnership, Matilda sat with William at his courts and witnessed around one hundred charters issued up to the momentous year of 1066. She would also accompany him across the country, to display an image of unity and preserve authority.

In William's many absences on campaign, Matilda was left in charge with his blessing; she had the power to raise taxes, dispense justice and make laws. Despite the political expediency of their marriage, Matilda and William were, to all appearances, devoted to each other and it's believed that William had no illegitimate children. Together, they founded hospitals in Bayeux, Cherbourg, Caen and Rouen. Matilda built a convent at Caen called La Trinite – and ultimately, she chose to be buried there.

With the death of William's distant cousin, King Edward the Confessor of England in 1066, William, who had spent the years since his marriage consolidating his power in Normandy, invaded, and attacked King Harold, Edward's successor. It's likely that Edward the Confessor, who had no heirs of his own, had promised William the throne on his death. But apparently, he changed his mind, in favour

of another English cousin, Edgar, who was just 12 years old at the time of Edward's death. Edward's brother-in-law Harold Godwinson seized the throne – and William came to fight for what was his.

William had an invasion force of 1,000 ships; aboard which were horses and 8,000 men (made up of Normans, Britons and Flemish troops). William's forces made the crossing to England in September 1066, and on 14 October his forces defeated and killed Harold.

The ship on which William sailed to England was a gift from Matilda, called the *Mora*. The ship list from the monastery at Fecamp, which acted as William's Invasion HQ, says of the *Mora*:

The duke's wife Matilda [...] in honour of her husband had a ship prepared called 'Mora' in which the duke went across. On its prow Matilda had fitted [a statue] of a golden child who with his right hand pointed to England and with his left hand held an ivory horn against his mouth. For this reason the duke granted Matilda the earldom of Kent.[6]

The *Mora* is depicted in the Bayeux Tapestry, the nearly 70-metre-long embroidered cloth that tells the story of William's conquest of England; it is thought to have been commissioned by William's half-brother, Odo, and was created by nuns in England during the eleventh century.

The Tapestry was scheduled to be returned to England on loan in 2022, almost 1,000 years after its creation. As an interesting aside, a Cambridge teacher spent six years recreating a full-sized replica version of the tapestry; Mia Hanson started the work in July 2016. She is reported to be so determined to create an authentic copy, spending at least ten hours a day at the endeavour, that she is including mistakes made in the original. She passed the halfway mark in January 2022, making 34 metres (112ft) of the 68m (224ft) artwork.

That hand that's turned the wrong way around, one bloke, he's got two right hands, no-one's going to notice which side his thumb is – I did. They did a job and they did a marvellous job. Who am I to correct their work – I honour what they've done, mistakes and all.[7]

When William went to meet, and defeat, Harold Godwinson at the Battle of Hastings, Matilda was left in charge as regent, despite their eldest son Robert being of an age to rule in his father's absence. Managing Normandy was no mean task, but Matilda was more than up for the challenge, ensuring relative peace and stability in William's absence.

William was crowned king at Westminster on Christmas Day 1066; Matilda couldn't be there as she was heavily pregnant with her youngest daughter Adela, who would be born in January 1067.

It wasn't until Easter 1068 that Matilda sailed to England to be crowned at both Winchester and Westminster Abbey. She continued to act as William's regent in Normandy, doing such a steadfast job that he was able to remain in England to consolidate his power. Matilda was popular and well-loved in the dukedom, acting as hostess to foreign envoys and ambassadors; she would travel back and forth between England and Normandy, depending on where William needed her.

William trusted Matilda's judgement implicitly, effectively allowing her to rule Normandy in his absence. There is even record of a monk who, having travelled to England to appeal to William, was told to return to Normandy and appeal to Matilda instead. Matilda performed the same duties in both Normandy and England, while also ensuring the households were well run and both she and William were dressed according to their status.

The relationship between William and his eldest son Robert was fractious at best, so much so that in 1077 Robert led a revolt against

his father. When Robert was forced to flee to Flanders, it was Matilda who sent him money to fund his next campaign against William, as well as messages of support. Matilda supporting their son instead of William caused a rift in the marriage; Robert had always been her favourite; William, however, saw him as a spoiled brat. Matilda was forced to publicly kneel and beg his forgiveness in front of the whole court; never again would she be trusted with the same level of power.

Matilda died on 2 November 1083 at the age of 51, no doubt drained from the strain of responsibilities of ruling, having given birth to at least nine children, the frequent travel, the stress of the factions with the family, and possibly plague. William was utterly distraught. In her will, she bequeathed money and property to her abbey at La Trinite. Two of her sons went on to become kings of England: William Rufus II and Henry I.

William died in 1087 at the priory of St Gervais near Rouen; the room in which his body lay was looted by his own staff – and his body left nearly naked (vii) William and Matilda were both buried in Caen; while she was at La Trinite, William was put in the abbey of St Etienne, which he had founded in 1063. When he was eventually being laid into his sarcophagus, the long delay and ensuing effects on his rapidly decaying body meant that when the monks tried to force his body in, his swollen bowels burst. The ensuing smell was so terrible that the majority of people in the abbey fled entirely.[8]

Matilda's tomb was desecrated by French Huguenots in 1562, her remains were then moved to a new tomb in 1702 which was disturbed again, this time during the French Revolution. She was finally laid to rest and reinterred in 1819. William's grave was disturbed several times, including on the orders of the Pope in 1522, then also desecrated by French Huguenots in 1562, leaving just a single thighbone. This was buried in a fresh tomb, which was then, as with Matilda, disturbed during the French Revolution before finally being laid to rest under a new marker on 9 September 1987, the 900th anniversary of his death.

Chapter 5

Anna Comnena/Komnene
(1/2 December 1083 – c.1153)

I swear by the perils the emperor endured for the well-being of the Roman people, by his sorrows and the travails he suffered on behalf of the Christians, that I am not favoring him when I say or write such things … I regard him as dear, but the truth is dearer still.

Anna Comnena, *The Alexiad of Anna Comnena,*
book 14, chapter 3

Anna was a princess, scholar, the only Byzantine female historian and one of the first historians in medieval Europe. Described as 'one of the best educated and most ambitious women of her day'[1] as the eldest child of Alexius Comnenus, Byzantine Emperor Alexius I from 1081 to 1118 and her mother Irene (Eirene) Ducas, she learned astronomy, classics, philosophy, music, mathematics, and medicine.

She is also a classic example of 'what if'; *what if* she had been born a man, because she had all the potential for a future emperor, but her gender was against her.

Born in the Porphyra Chamber of the Imperial palace of Constantinople a few years after her father seized the Eastern Roman Empire from Nicephorus III, Anna was betrothed as a child to Constantine Doukas, her father's co-emperor.

Tradition dictated that she was brought up in her future mother-in-law's household. Anna wanted to rule after her father and it was expected that she would do so with Constantine by her side, but those plans were upended on the birth of her younger brother John on 13 September 1087 who, as a male, automatically jumped ahead of her in the succession queue. Doukas was forced to step aside and died not long afterwards in 1095.

Anna wrote on medicine, ran a 10,000-bed hospital and orphanage in Constantinople at the behest of her father, and became somewhat of an expert on gout, from which her father suffered. Her status as the daughter of an emperor meant she was well versed in history, geography, and military strategy.

The expectations for women at the time were profoundly low. Possibilities included looking after the family, remaining unseen as much as possible, remaining virtually hidden in living quarters known as gyneceum, covering their faces with veils and avoiding public processions.

Anna, however, was inspired by the achievements of women such as her own grandmother, Anna Dalassena, who openly ruled as regent during the early years of her son's reign. The elder Anna bore eight children and was extremely ambitious for her family, effectively running it after the death of her own husband in 1067. Indeed, Anna's admiration for her grandmother was profound: here was a woman whose son actively raised her in positions of honour and power – arguably giving her complete power so that he could wage warfare against his barbarian enemies. Anna writes of the relationship between mother and son:

He loved her exceedingly and depended on her for advice (such was his affection for her). His right hand he devoted to her service; his ears listened for her bidding. In all things he was

entirely subservient, in fact, to her wishes. I can sum up the whole situation thus: he was in theory the emperor, but she had real power.[2]

She imagines her father as running alongside his mother's proverbial imperial chariot while her grandmother used her 'excellence, her good sense, and her remarkable capacity for hard work' to act as chief administrator of state affairs, select appropriate civil servants and manage revenues and finances.

Anna believed her indomitable grandmother,

...capable of governing not only the Roman Empire but also every other kingdom under the sun ... She was very shrewd in seizing on whatever was called for, and clever in carrying it out with certitude. Not only did she have an outstanding intelligence, but her powers of speech matched it. She was a truly persuasive orator, in no way wordy or long-winded...She was ripe in years when she ascended the imperial throne, at the moment when her mental powers were at their most vigorous.[3]

At the age of 14, Anna married historian Nicephorus Bryennius. Together for forty years, they had four children: Alexius Comnenus (b. 1098); John Ducas (b. 1100); Irene Ducas or Ducaena (b. ca. 1101/1103); and a daughter whose name is thought to have been Maria.

She stood firmly by the side of her mother Empress Irene as together they tried to persuade her father to disinherit John in favour of her husband, Byrennius. He was the leader of Bryennium, a favourite of her father and a Byzantine soldier, statesman and historian who fought in the First Crusade. By placing him on the throne, Anna would automatically join him.

Her father grew ill with rheumatism around 1112 and turned over administration of the kingdom to his wife Irene and Byrennius. While Anna used her medical knowledge to care for him, he died in 1118, with John having laid the groundwork for his reign, by securing the essential support of military and government leaders, and apparently grabbing the imperial ring from the nearly cold, dead fingers of his father.

It's believed that Anna tried to raise her own army to fight for her right to rule, but that it was a futile endeavour, as she writes: 'My own lot has been far from fortunate …. I have not enjoyed good luck … full of troubles, full of revolution … I have been conversant with dangers ever since my birth.'[4]

John ruled as emperor between 1118 and 1143. A warrior ruler, all his efforts were focused on reconquering Byzantine lands lost to the Turks, Arabs and Christian Crusaders. Anna doggedly tried to throw him off his throne; her husband, however, refused to support her, disappointing her in the extreme. She made it clear that if she would have been born a man, she would have taken the action needed; in short, she was disgusted with his lack of ambition.[5]

Indeed, she wrote: 'Nature had mistaken the two sexes and had endowed [her husband] with the soul of a woman.'[6]

With hindsight, perhaps had she been born a man, she would have succeeded her father as emperor. Nonetheless, her plot was discovered, she and Nicephorus were ordered to leave court and Anna forfeited her estates. When Nicephorus died in 1137, Anna and her mother went to the convent of Kecharitomene, of which Anna was the governor and which Irene had founded several decades earlier; it's thought that they would have had comfortable and spacious quarters with plentiful food, and that it was more of a retirement than a forced move.

It was here at the age of 55, thoroughly isolated and her ambitions thwarted, that she returned to her beloved studies, focusing on

philosophy and history and running intellectual 'salons' or gatherings. Hugely intelligent, the Bishop of Ephesus proclaimed she had reached 'the highest summit of wisdom, both secular and divine.'[7]

She also began chronicling her father's reign, completing the work begun by her husband. The fifteen-volume biography, the *Alexiad*, is written in Greek and is Anna's only literary work. It is the only surviving Greek account of the violent and bloody First Crusade, the first of a series of bloody religious wars, with Christian knights from Europe battling to reclaim Jerusalem from what they regarded as the Muslim infidel. It's also described as the main source of Byzantine political history across the eleventh and twelfth centuries. The work secures Anna's place as the only female Greek historiographer of her time.

While the exact date of her death is unknown, it's thought that Anna died between the ages of 70 and 72, sometime between 1153 and 1155, at the Monastery of Kecharitomene. In 1204, around fifty-one years after her death, her beloved Constantinople was brutally sacked by the western Christian army of the Fourth Crusade, which had been launched by Pope Innocent III in 1202 with the express purpose of reclaiming it for Christendom following its fall to Saladin in 1187. The great city was besieged thirty-four times throughout its history; historian J.J. Norwich summarises the impact of the 1204 sacking: 'By the sack of Constantinople, Western civilisation suffered a loss greater than the burning of the library of Alexandria in the fourth century or the sack of Rome in the fifth – perhaps the most catastrophic single loss in all history.'[8]

The Alexiad was finally translated into English in 1928 by British Classics scholar Elizabeth Dawes, who, fittingly, was the first woman to receive a doctorate in literature from the University of London.

Chapter 6

Morphia/Morfia of Melitene/Melitine (c. 1075 – October 1126)

Morfia herself is a shadowy figure, rarely mentioned in chronicles or even charters, the classic example of a woman who seems no more than a pawn. But there must have been a deep strength and intelligence in her, as the few hints about her life with – and often without – her husband will show.[1]

Armenian links to Jerusalem go back to the fourth-century AD, when the country adopted Christianity and Armenian monks settled there; One of the oldest countries in the world, Armenia's recorded history reaches back 3,500 years; a 2006 survey estimated that around 800 Armenians still lived in Jerusalem.

Little, however, is known of Morphia – she is perhaps better known for the women she left behind – her four daughters Melisende, queen of Jerusalem, Alice of Antioch, Hodierna of Jerusalem, and Ioveta of Bethany.

The first woman to be crowned queen of Jerusalem, Morphia was a daughter of Armenian nobleman, Lord Gabriel of the wealthy town of Melitine, which was on the trade route from the Persian Empire to the West.

She was 25 years old when she was married to Baldwin II, Count of Edessa and king of Jerusalem – a match considered astute. While we can only guess at her thoughts on the match, for Baldwin it would

strengthen bonds between the Armenian community of Edessa and the French Crusaders. Morphia's dowry included 50,000 gold bezants, more than the annual income of Edessa. The money was swiftly invested on the military and building infrastructure.

By 1104, she was pregnant with their first daughter, the future Queen Melisende; the baby was born in 1105 without its father present; after losing a battle during an 1104 raid on the nearby Muslim town of Harran, Baldwin had been taken hostage in Mosul. With her own father having died without paying Morphia's dowry in full, she didn't have the money to free Baldwin. Her desperate situation was not unique in the Crusader states. According to Sharan Newman in *Defending the City of God*:

> Women were left to cope when towns and estates were attacked, their fathers or husbands gone to battle, captured, or slain. There are even reports of men of fighting age fleeing towns under attack, leaving their families to be slaughtered or enslaved.[2]

Ultimately, with Baldwin away for so long, Morphia was only able to introduce their first daughter Melisende to him when she was 3 years old. This speaks of the strong influence Morphia, with her Armenian heritage, would have had on her daughters – being the main parental influence on their upbringing, and the fierce loyalty they had to each other, *"even willing to call in hits on the men who were ruining a sister's life."*[3]

While, as we will see throughout the profiles in this book, marriages in the Middle Ages were rarely love matches, and more likely to be for political, social and economic alliances, Baldwin was a loyal and devoted husband. He refused to cast his wife aside, even when it became clear that she would not provide any male heir.

While he came to the Jerusalem throne in April 1118, he delayed his own coronation until 25 December of that year so that his wife

could be crowned beside him and made queen consort. On a surface level, this reflected what would be her traditional supporting role rather than that of a hereditary queen regnant. However, she was no quiet wallflower, content to rest in the shadows of her husband. Morphia was extremely powerful in her own right.

The coronation would have been an event of singular significance and splendour. It took place on Christmas Day 1118 in the Church of the Nativity, Bethlehem, the date chosen for its political, religious, and symbolic expediency; it was also the day Charlemagne had been crowned Holy Roman Emperor in Rome in the year 800. The site was the place of Christ's birth and where David had been made king of Israel. The Patriarch of Jerusalem would have anointed them with holy oil as they kneeled before him, the act symbolising their transformation from mortals to God's own representatives on earth.

To have reached the point of coronation, Baldwin and Morphia had endured tremendous challenges and personal sacrifices. Baldwin was merely the second son, with little expectations by way of inheritance. Yet he had experienced adventures, battles, capture and imprisonment. And throughout two decades, Morphia had stood firmly by his side, borne him three daughters and protected his lands while he languished in Saracen prisons.[4]

While there is no surviving description of the event, it can be assumed that it was a lavish spectacle. In attendance were Morphia's three daughters, Melisende, Alice and Hodierna, aged 13, 8 and 7 years respectively. Their parents' coronation made them princesses of Jerusalem and a new matriarchal line of powerful women in Outremer. (Outremer refers to the Crusader States, the four Roman Catholic entities in the Middle East, that lasted from 1098 to 1291).

The formidable character of her daughters was inherited from Morphia; for when Baldwin was captured by the Turks in 1123, it was she who hired Armenian mercenaries to try and discover his location.

A year later, having conducted negotiations on her husband's behalf, in desperation she offered up their youngest daughter Ioveta (or Yvette) when the child was just 3 years old. The child remained as a hostage for two years in Shaizar, Syria, in exchange for Baldwin's freedom; likely tainted by association because of her capture and imprisonment, Ioveta later went on to become a nun/abbess at the convent founded by her elder sister Melisende at the Tomb of Lazarus in Bethany, from where, in fateful family symmetry, she would educate Sybilla, Melisende's granddaughter.

According to the Melisende Psalter, an illuminated manuscript commissioned around 1135 for Queen Melisende, (a hugely significant manuscript from the Crusader Kingdom. The Psalter is a volume of the 150 Psalms or ancient songs grouped together to form one of the Old Testament Books of the Bible; they are said to have been composed by King David), Morphia died on 1 October, a few years after having been reunited in 1125 with Ioveta, possibly 1127 but the actual year is uncertain. She was buried at the Tomb of the Virgin in the valley of Jehoshaphat, just outside Jerusalem, in the late 1120s.

Significantly, Baldwin's decision not to remarry following Morphia's death, in a move which may have at last secured a male heir, meant that his daughters were indisputably the next generation of rulers of the Kingdom of Jerusalem.

Chapter 7

Heloise d'Argenteuil
(c. 1098 – 19 May 1163)

Abelard and Heloise lived 900 years ago. Their story – a mixture of spiritual quest, erotic passion and horrific brutality – is probably the most memorable tale of all from the Middle Ages.

Heloise and Abelard, James Burge,
Sharpe Books, 2018.

Accstruction to Susan Signe, the love affair between Heloise, known as the most educated woman in Europe, and Peter Abelard, (1079 – April 21, 1142) the most brilliant philosopher of his age, 'became the gossip of Paris' and 'the biggest scandal of the medieval European world.'[1]

Heloise was renowned for her intellect and education at a time when educated women were extremely rare. Unsurprisingly, very little is known of her birth or upbringing. She was likely born around 1100 and may have been the daughter of a noble, or alternatively she was illegitimate. Either way, she was left in the care of her uncle Fulbert, with her early schooling taking place at the convent of Argenteuil, near Paris. It's believed that she was soon well known for her intelligence and learning.

Peter Abelard was the son of a knight in Brittany. He rejected his noble military inheritance to instead study philosophy and logic. He was reputed to have a brilliant mind, and allegedly never lost an argument.

Heloise's uncle, Canon Fulbert, was a member of the clergy at the cathedral of Notre Dame in Paris. Knowing Abelard's impressive intellectual reputation, when Heloise returned to her uncle in Paris around 1116 or 1117, he tasked Abelard to act as a private tutor in classics and philosophy to his niece, offering him bed and board to further accommodate their learning. His determination to secure additional learning of such repute for his niece surely indicates a great affection between the two.

Of their first encounter, Abelard wrote: 'In looks she did not rank lowest while in the extent of her learning she stood supreme.'[2] Clearly, he began to teach her more than philosophy: 'My hands strayed oftener to her bosom than to the pages. To avert suspicion, I sometimes struck her. (Our) desires left no stage of lovemaking untried, and if love devised something new, _we welcomed it_.'[3]

Their love letters were likely written using wax tablets that 'hinged like a book and were carried from sender to recipient by a servant; after the letter was read, the wax could be smoothed by a candle and used again.'[4]

It's thought that Heloise wrote the first drafts of her letters on parchment, and it is these that have survived. Some of Abelard's passionate letters were copied and shared among his students and the people of Paris. It wasn't long before rumours of their two-year affair reached Heloise's uncle, who was furious. By that time – and given that Heloise and Abelard had sex in convent kitchens and in her uncle's bedroom and indulged in 'far-ranging sexual experimentation',[5] unsurprisingly, Heloise was pregnant. She travelled to Brittany, allegedly disguised in a nun's habit in order to flee the city, where Peter's sister lived, to give birth to their son, Astrolabe (the sailor's must-have scientific instrument which predicted the position of the sun, planets and stars).

Heloise's uncle wanted them married. While Abelard capitulated to the idea, it was Heloise who was firmly against it. Being married would ruin Peter's trajectory in the church, as only unmarried priests could advance the career ladder. It was Heloise too who cited several anti-marriage works, written by men, in her rebuttal, arguing that it would be impossible for a man to devote himself equally to philosophy and a wife and family.

However, to protect Peter's career, they married in secret and then took vows of celibacy. On discovering the news, her uncle was incandescent with rage and Heloise was forced to flee once again, returning to the convent of Argenteuil, a northern French town, along the north bank of the river Seine, where her early education had begun.

At Fulbert's bidding, Peter Abelard was attacked in the night and brutally punished with castration by members of her family: 'They cut off the parts of my body whereby I had committed the wrong of which they complained.'[6]

Fulbert's view was that Abelard had dishonoured his family; Abelard claimed that the shame of the castration was more intense than the pain he suffered during it.

According to his memoirs, the morning after the brutal punishment, the people of Paris gathered at his home. The Bishop of Paris ordered that he be fired as master of the cathedral school. Fulbert was also penalised for the scandal; his assets were seized, and he was out of favour for around two years.

Banished, Abelard became a monk at the monastery of St Denis and detailed his experiences in *Historia Calamitatum* or *History of my Troubles*, written around fifteen years after his marriage to Heloise.

Heloise became prioress of the Argenteuil convent (which had been founded in the seventh century) in 1118. She was expelled from it in 1129 and the convent turned into a monastery. Abelard gifted

Heloise and her nuns the property of Paraclete (named after one of his philosophical arguments) and it was there that Heloise became Abbess of a new foundation of nuns.

Heloise and Abelard never lived together again and were estranged for over a decade, until she learned that he had written their story, *Historia Calamitatum* (Story of My Misfortunes). He refused to visit her, stating that 'My agony is less for the mutilation of my body than for the damage to my reputation.'[7]

Heloise and Abelard created a collection of all their correspondence, which began in 1132, over three decades after the First Crusade and fifteen years before the second, including love letters and epistolary dialogue.

Their correspondence, often still sexual in nature, continued until Abelard's death in 1142, after which Heloise received a letter from Abbot Peter the Venerable, in which he complimented her on having 'surpassed all women in carrying out your purpose, and have gone further than almost every man'.[8]

Some critics have argued that Heloise, despite her incredible education and writing, is far from the feminist heroine that some paint her as. 'Nobody who takes the veil on the command of her husband and swears "complete obedience" to him can hope to sneak into the bastion of feminism. Today, even the high romance of the couple's liaison strikes us as foreign: all that sacrifice and intensity!'[9]

Heloise continued to head the religious foundation, Paraclete, and remained abbess until her death on 19 May 1163. Buried alongside each other, they were later interred by Josephine Bonaparte, wife of Napoleon, to the Pere-Lachaise cemetery, east of Paris.

Heloise is therefore, rightly 'celebrated mostly for being a female intellectual in a period when there were few.'[10]

Chapter 8

Melisende, Queen of Jerusalem (1105–1161)

We have no portrait of her. There are no surviving letters or diaries written by her. She is mentioned, mostly in passing, in histories of the Crusades, for she was a Crusader queen. Her reign was right in the middle of the twelfth century, and bridges the time between the establishment of the Crusader kingdoms in 1099. The rule of the first Crusaders, and the loss of Jerusalem to the Muslims in 1187. All the more amazing is that this is not a current figure, but a woman who lived and prospered nine hundred years ago.

Melisende of Jerusalem, The World of a Forgotten Crusader Queen,
Margaret Tranovich, East & West Publishing, 2001.

The First Crusade (1096–1099) was a military campaign aimed at 'recapturing' Jerusalem from the Islamic rule it had been under since the seventh century. Pope Urban II wanted Jerusalem to become a Christian city again. In July 1099, Jerusalem was finally captured. The challenge then was holding onto it. Four Crusader states were created: the kingdom of Jerusalem, the principality of Antioch, and the two counties of Tripoli and Odessa.

Historians place Melisende firmly alongside contemporaries Eleanor of Aquitaine and Empress Mathilda as among the most powerful women of the twelfth century. She became the first queen of Jerusalem from 1131 to 1153 and was also regent for her son from 1153 to 1161. Her parents were Morphia of Melitene and Baldwin II

of Jerusalem. As described in Morphia's profile, Melisende was the first of four daughters; her sisters were Alice, princess of Antioch; Hodierna, countess of Tripoli; and Ioveta, abbess of St Lazarus in Bethany.

With no male heir, Melisende's father trusted in her intelligence and ability to administer the needs of the kingdom while he was away fighting. Accordingly, from an early age she was taught how to run the kingdom and her signature was given on several documents to cement her authority in her own right and demonstrate that she was being groomed for queenship. One document bears her witness as 'Milisenda filia regis et regni Jerosolimitani haeres', daughter of the king and heir to the kingdom of Jerusalem.[1]

She would, however, need to be married to claim the throne. With the death of her mother Morphia in October 1126, and Melisende designated the royal heir, her father sent word to the king of France that he was looking for a suitable husband for his 23-year-old daughter. The answer came in the form of the powerful, rich, and influential crusader Fulk, Count of Anjou, whose son Geoffrey had married the Empress Mathilda, heir to the throne of England and Normandy.

It will come as no surprise that in keeping with most historical marriages, theirs was not a love match, but one of political expediency. Fulk had already met Melisende's father while on pilgrimage to Jerusalem in 1120; a 40-year-old widower, he relished the opportunity of becoming king of Jerusalem.

They were married on 2 June 1129 at the Church of the Holy Sepulchre when Melisende was 24 years old. Their son Baldwin, named after his grandfather, was born within a year.

Muslim travel writer Ibn Jubayr described the bride thus:

'She was most elegantly garbed in a beautiful dress from which trailed a long train of golden silk. On her head she wore a gold

diadem covered by a net of woven gold, and on her breast was a like arrangement. Proud she was in her ornaments and dress, walking with the little steps of half a span, like a dove, or in the manner of a wisp of cloud. God protect us from the seduction of the sight.'[2]

On his deathbed, on 21 August 1131, Baldwin II made it clear to the nobles and churchmen present as witnesses that Melisende, Fulk and their young son, the future Baldwin III, were to be on an equal footing within the kingdom. This is not likely to be something Fulk had anticipated – he would have wanted to rule solo. It was, however, an absolute reflection of the ailing king's belief in his eldest daughter's ability and right to rule as a woman.

Baldwin II was buried alongside the previous rulers of Jerusalem, Godfrey and Baldwin I, in the Church of the Holy Sepulchre, and no sooner had he been laid to rest than, for want of a more genteel description, it all kicked off between the new husband and wife team of Jerusalem.

Fulk began behaving as if he was now sole ruler, excluding his new wife from the charters of the kingdom. The Chronicle of Orderic Vitalis describes how:

To begin with [Fulk] acted without the foresight and shrewdness he should have shown and changed governors and other dignitaries too quickly and thoughtlessly. As a new ruler he banished from his counsels the leading magnates who from the first had fought resolutely against the Turks and helped Godfrey and the two Baldwins to bring towns and fortresses under their rule, and replaced them by Angevin [its Empire included England, the duchies of Normandy, Gascony, Aquitaine as well as Anjou] strangers and other raw newcomers…; turning out the

veteran defenders, he gave the chief places in the counsels of the realm and the castellanships of castles to new flatterers.[3]

In addition, Fulk outrageously accused Melisende of having an affair with her cousin, Hugh II of Le Puiset, Count of Jaffa. Although the flirtation had started as nothing more than gossip, talk of it quickly developed into a full-blown political crisis. Under Frankish law, a woman found guilty of adultery would be punished with 'rhinotomy' (nose-slitting) and the man would be castrated. As queen, however, Melisende was unlikely to be punished.

The episode descended into outright aggression and civil war. Hugh, the most powerful baron in the kingdom, was challenged to prove his innocence via single combat, (a duel between two individuals, representing a battle between the two kingdoms and armies they represent). He ran to Egyptian territory and returned only when the church intervened, forcing Fulk to offer terms to quit and Hugh agreed to be exiled for three years.

On his eventual return to Jerusalem, Hugh was stabbed in the streets of Acre by a Breton knight. While he survived the attack (only to die three years later in Sicily), Jerusalem fell into uproar, the people convinced that Fulk himself had commissioned an assassination attempt. The Breton knight in question was tried, found guilty and sentenced to dismemberment. With his tongue left intact, even as the rest of him was ripped apart, the knight insisted that Fulk was innocent.

Let's consider the fact that an accusation of sexual promiscuity was used in an attempt to undermine a female ruler. Would a male ruler have been put under the same scrutiny and criticism? Unlikely. Sexual politics indeed.

Contemporary historian William of Tyre reported that Fulk was in fear for his life; there was substantial public sympathy for Hugh and absolute outrage from Melisende;

Fulk had won the battle but lost the war. He had discovered he could not rule Jerusalem as he had Anjou. He could not impose his own counselors or ignore the men (and their sons) who had conquered his kingdom one bloody mile at a time. Most important, he could not replace his wife at whim but must recognise her as her father had intended as his co-regent, his equal in power.[4]

After the husband and wife were eventually reconciled sometime in 1135, Melisende's name reappeared on royal charters. Fulk made sure to incorporate his wife into the ruling of the kingdom. A powerful patron of the arts and the church, Melisende was politically savvy enough to spend where it mattered; across churches and other religious institutions, where it was more acceptable for a medieval woman to offer patronage and where she could expand her sphere of influence.

Melisende founded an abbey at Bethany in 1138 and commissioned a personal prayer book, the Melisende Psalter, a hugely significant manuscript from the Crusader Kingdom. The Psalter is a volume of the 150 Psalms or ancient songs grouped together to form one of the Old Testament Books of the Bible; they are said to have been composed by King David. Richly decorated, its original binding incorporated ivory panels, carved with scenes from the life of David.

Melisende also financially supported the rebuilding of Jerusalem's most important pilgrimage site, the Church of the Holy Sepulchre. It was dedicated in 1149. She built St Anne's Church, north of the Temple Mount, on the site of the Bethesda Pool and it survives as an example of Crusader architecture; its convent was extremely wealthy and well endowed. If you look closely at some of the shops, they bear the mark 'ANNA' to illustrate where the money was spent, whilst

others denote where Templar money went, and are marked 'T' for the Temple.

Melisende, like her mother, was no shrinking violet. She refused to be a passive partner in her marriage. She was an absolute fighter, had a will of iron and was extremely determined – especially when her hereditary rights and power were questioned. Her right not just to inherit the power – or title of monarch were both recognised by the High Court (i.e., her vassals) and defended by her barons and the church.[5]

Faulk and Melisende ruled jointly until he died in 1143 after being thrown from his horse in a hunting accident outside the city of Acre. Fulk, like his father-in-law, was buried in the Church of the Holy Sepulchre.

Just a few weeks later, their 13-year-old son was proclaimed King Baldwin III (their younger son Amalric was 6 at the time), and Melisende was crowned queen for the second time; William, the patriarch of Jerusalem, conducted the ceremony. Because of Baldwin's young age, Melisende acted as regent in his stead, with the action unanimously approved by her council. Although a shrewd administrator of the kingdom, as a woman she was unable to lead it into battle or take part in any military campaign. She was wholly reliant on the goodwill and loyalty of her nobles to do her bidding in this arena.

William of Tyre writes that:

Melisende … had risen so far above the normal status of women that she dared to undertake important measures. It was her ambition to emulate the magnificence of the greatest and noblest princes and to show herself in no wise inferior to them. … she ruled the kingdom and administered the government with such skilful care that she may be said truly to have equalled her ancestors in that respect.[6]

She has been criticised for putting her ambition ahead of the security of Jerusalem. She had the power – and didn't want to give it up, for anyone. Despite Baldwin coming of age when he turned 15, Melisende stubbornly continued to rule in his stead. Initially they reached an agreement whereby the kingdom was split; Melisende would rule Jerusalem, Nablus and the coast, while Baldwin would have Galilee and the north. Melisende, however, still maintained a great deal of political power and influence and a divided kingdom would make for easy pickings for enemy Muslim forces. By the time Baldwin reached twenty in 1150, he was becoming increasingly frustrated with the situation until finally, in 1152, he felt he had no choice but to rebel against his mother. He gathered an army and launched a civil war against her.

Melisende's name can be seen on royal charters up to 1157. William of Tyre describes her eventual death:

> Transcending the strength of women, the lady queen, Melisende, a prudent woman, discreet above the female sex, had ruled the kingdom with fitting moderation for more than thirty years, during the lifetime of her husband and the reign of her son.[7]

She was buried in the same place as her mother Morphia, at the Tomb of the Virgin in Jerusalem.

Chapter 9

Melisende's Sisters: Alice of Antioch (c.1110 – after 1136)

Also known as Alais or Alix, Alice was the second daughter of King Baldwin of Jerusalem and Queen Morphia, and sister to Melisende, Hodierna and Ioveta.

Born in the kingdom of Jerusalem in 1106, Alice would have been intelligent and educated like her sisters. In 1126 she married Bohemond of Antioch; after he was killed in an attack on Damascus just four years later (when he was beheaded and his head embalmed and sent to the caliph in Baghdad) she assumed regency of the kingdom on behalf of their 2-year-old daughter Constance (Constance of Hauteville, 1128–1163). It could be argued that having seen the power her sister Melisende wielded, she assumed that she could do the same.

Her father Baldwin, as well as the people of Antioch, had other ideas. However he felt about Melisende, he'd still had to bring in Fulk as her husband to maintain equilibrium in the unstable region.

They wanted a military man in place, but Alice had other ideas and launched the first of three coups. She sent a message to Turkish general and prince Zengi, ruler of Aleppo and Mosul, offering her tribute and loyalty in exchange for an alliance and his support in keeping her in charge. The message was intercepted by Baldwin, and he was furious. The messenger was hanged for treason and, firmly quashing Alice's ambitions, he banished her to Lattakieh (Syria)

which he had given to her as part of her original marriage dowry and forced her from the regency. Sir Joscelin of Odessa took her place as regent, and it's believed Constance remained in Antioch cared for by palace staff.

Soon after the death of their father in 1131 and the ascension to the throne of Melisende and Fulk, Sir Joscelin also died. Alice decided to return to Antioch from exile. In another futile attempt to gain the upper hand in management of her daughter's future, she then sent word to Constantinople – offering Constance as a potential bride to the emperor's son. But she'd underestimated the machinations of the nobles in Antioch. They wanted Constance married to someone who would take over; anyone, it would seem, other than Alice herself. She tried, for a third time, to establish herself as regent between 1135 and 1136. When the ruling patriarch, Bernard of Valence, died and left an opening in the running of Antioch, she seized power again on behalf of Constance, who was now eight years old. Beyond frustrating for her, she was once again outmanoeuvred, her machinations no match for the new patriarch Ralph, former archbishop of Mamistra, who gave power instead to Raymond of Poitiers.

Raymond, Eleanor of Aquitaine's uncle, feigned interest in Alice, convincing her he wanted to marry her; what he did was secretly marry Constance in 1136, becoming ruler of Antioch and having four children. He was killed in the Battle of Inab in 1149, beheaded by Shirkuh, the uncle of Saladin. His head was placed in a silver box and sent to the Caliph of Baghdad as a gift. Constance was left a widow at the age of twenty two.

An utterly bested Alice returned to Syria where she died after 1136, her life perhaps an example of how some can play the game to win – and others to lose.

Chapter 10

Hodierna of Jerusalem (c.1110–1164)

Her story and what we know of her is largely defined in relation to the men in her life. The third of Baldwin and Morphia's three daughters, Hodierna was a princess of Jerusalem, and Countess Consort of Tripoli through her marriage to Raymond II of Tripoli. She was Regent of Tripoli during the minority of her son, Raymond, between 1152 and 1155.

They had two children, Melisende (named after her aunt) and Raymond (after her father). It was not a happy marriage. It is said that her husband was extremely jealous and doubted that he was the father of his own daughter. During a difficult time in their marriage in 1152, he kept Hodierna secluded – literally locked away from society to control her.

Hodierna and her sister Melisende were close, being mutually supportive during each other's marital and life struggles; Melisende and Hodierna's nephew Baldwin both came to try and intercede as intermediaries. While the couple decided to reconcile, the decision was made for Hodierna to travel back to Jerusalem with her sister; Raymond had travelled part of the way with them, but the two women continued the journey without him. En route, a messenger caught up with them to break the news that Raymond had been murdered by assassins at the gates of Tripoli. A tragic accident or an act of vengeance orchestrated by a concerned older sister? Raymond has the dubious distinction of being the first Christian ruler to be murdered by assassins.

In any event, Hodierna went home to become regent for her 12-year-old son, Raymond III, until he reached his majority in 1155. She is also rumoured to have possibly been the 'Distant Princess' that inspired Jaufré Rudel of Blaye (a troubadour, or musical performer, known for developing the theme of 'love from afar', and who likely died during the Second Crusade, in an attempt to see her) to write songs about her, despite never having met her. It was Hodierna who remained by her sister Melisende's side as she died in 1161; she herself died probably later in the 1160's.

Chapter 11

Joveta/Ioveta of Bethany
(c.1120 – between 1161 and 1178)

The fourth and youngest of the Baldwin and Morphia progeny; like her sisters, Ioveta was a princess of Jerusalem. She was also an Abbess of Bethany. When she was around three or four years old, she spent a year as a political hostage in a northern Syrian palace, to protect her father Baldwin, who had been captured by Muslim military leader, Balak the Ortoqid, who wanted to negotiate for his release.

When Balak died, his successor Timurtash decided that money was a better option and demanded a huge ransom. With Baldwin's wife, Morphia, only able to provide some of the money, Ioveta was offered up as collateral for the outstanding payment. She was handed over in June 1124, together with some other children of the Frankish nobility.

Ioveta never married nor had children; it was usual for the youngest daughters of nobility to join the church, which she did in 1136 when she joined the convent of St Anne of Jerusalem, where she remained for a couple of years until her oldest sister, Melisende, became queen and decided her youngest sibling could do better.

Melisende bought the village of Bethany and built a convent dedicated to St Lazarus, endowing it with surrounding property to ensure it was wealthy. When Ioveta was eighteen, she moved in as Abbess. She would later return to the family's royal palaces to

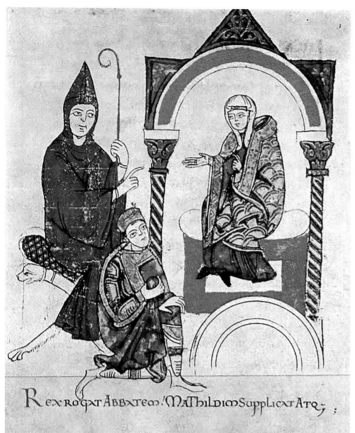

Holy Roman Emperor Heinrich IV (kneeling) asks Abbot Hugo of Cluny to intercede on his behalf with Matilda of Tuscany (right). (*Codex Vat.lat.4922, fol. 49r.*)

English royal family tree during the Wars of the Roses.

Diploma of Philippe I of France featuring the Cyrillic signature of his mother Anna of Kiev. (*Bibliothèque Nationale de France, Département des Manuscrits, Picardie 294, 38*)

Eleanor Cross at Hardingstone, constructed between 1291 and 1292. The cross is largely intact, but has been restored several times.

The funeral of
Isabeau of Bavaria, as
depicted in the French
manuscript Les Vigiles
de Charles VII, in 1484.
(*Bibliothèque Nationale
de France, Manuscrit
Français 5054, fol. 87r.*)

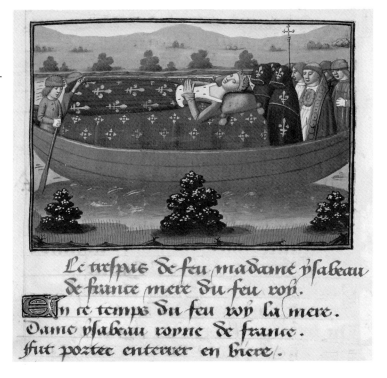

Le trespas de feu madame ysabeau
de france mere du feu roy.
En ce temps du feu roy la mere.
Dame ysabeau royne de france.
fut portee enterrer en biere.

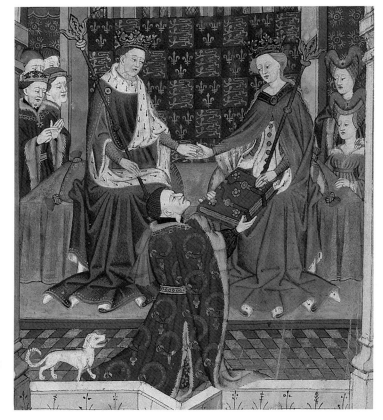

John Talbot presents
the Talbot Shrewsbury
Book to Henry VI and
Margaret of Anjou as
their courtiers watch.
With her unbound,
blond hair, Margaret
is depicted as a perfect
queen and embodiment
of the Virgin Mary.
(*British Library Royal
MS 15 E VI, fol. 2v.*)

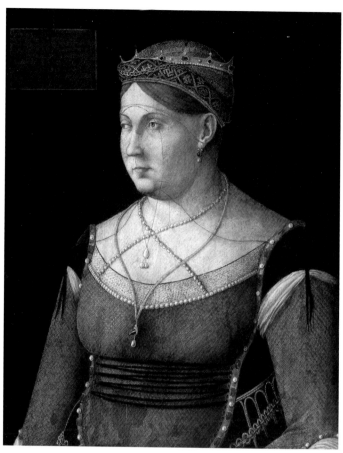

Portrait of Caterina Cornaro
by Gentile Bellini, ca. 1500.

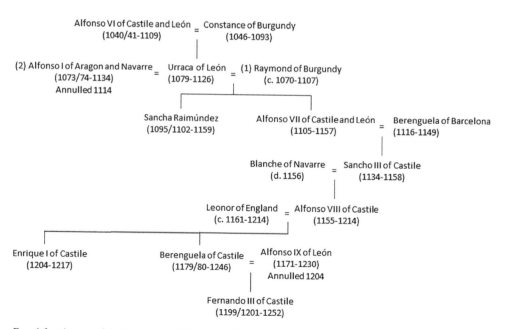

Royal family tree of the kingdoms of Castile and León during the reigns of Urraca and Berenguela.

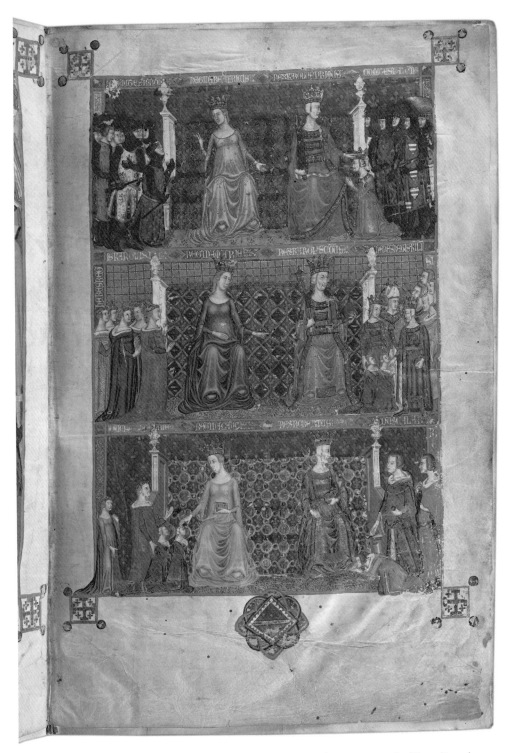

Frontispiece of the Anjou Bible, symbolically depicting the line of succession to the Neapolitan throne. The bottom panel shows King Robert of Anjou and his wife Sancia of Majorca. To Sancia's left, her granddaughters Giovanna and Sancia kneel. To King Robert's right, Giovanna's first husband Andrew of Hungary kisses the king's feet. (*KU Leiven Maurits Sabbe Library, fol. 4r.*)

Fresco depicting Tamar of Georgia at Betania Monastery in Georgia

Tomb of Inês de Castro.

Jean Fouquet, *Madonna Surrounded by Seraphim and Cherubim*, ca. 1452. The painting famously depicts Agnès Sorel as the Virgin Mary.

look after Melisende after she suffered a stroke. She and her sister, Hodierna of Tripoli, remained with Melisende until her death in November 1161.

Abbess Ioveta then returned to Bethany, where she died sometime after 1162.

Chapter 12

Eleanor of Aquitaine (1122–1204)

A medieval force to be reckoned with, Eleanor was Queen Consort of France (1137–1152) and England (1154–1189). She was also Duchess of Aquitaine in her own right (1137–1204). Powerful, influential and one of the wealthiest women in Europe, her name, eventful story and legend survives over 800 years after her death.

Born in southern France, her father was William X, Duke of Aquitaine. Aquitaine was huge – the duchy covering over a quarter of modern-day France.

Highly intelligent, well educated in literature, philosophy and languages, Eleanor was also a formidable horsewoman. At the age of fifteen, upon the death of her father, she inherited a huge estate and was promptly betrothed to Louis, the son and heir of Louis VI king of France, the latter of whom had sent a retinue of no less than 500 soldiers to accompany Eleanor to her new home. The two were married in July 1137 and on Christmas Day the same year, following the death of Louis's father the king, became the newly crowned king and queen of France. They had two daughters, Marie (born in 1145) and Alice (1150), but not the male heir that was a prerequisite of 'successful' royal unions.

Their reign witnessed an appalling massacre in the town of Vitry; several locals under siege took refuge in the church. Louis's forces set fire to it. Consumed with guilt, the politically naive Louis, joined by Eleanor, vowed to join the Pope's call for a crusade in 1145 to avenge

the overrun crusader county of Edessa. Louis would travel separately from his wife, to fulfil his crusader vow of chastity.

The call to Crusade was a tempting one: potential Crusaders were offered a clean slate for all their confessed sins, legal protection against any lawsuits taken against them after taking the Cross as well as an opportunity to raise funds by pledging land to churches or other Christians. Together with Eleanor, the countesses of Toulouse and Flanders, Mamille of Roucy, Florine of Burgundy and Torqueri of Bouillon accompanied their husbands. It's thought that at least three hundred women additionally travelled with them, as well as the ladies' servants.

The Crusade was a disaster for Christendom as well as the royal couple's reputations. The German Crusaders, who had departed before them (under the Holy Roman Emperor Conrad III) left a name for themselves for such poor behaviour that many following crusaders found themselves banned from the same cities. They were also roundly defeated by Turkish forces. The French party was consistently attacked en route; they faced torrential rains with their tents and supplies washed away. With their forces and resources depleting rapidly, and against sound advice, Louis decided to cross inland across the mountains, despite not having any guides. The starving army survived on horsemeat.

Disaster struck again when two Poitevin nobles, together with Eleanor, independently decided that they would set up a camp in a place completely different to that which had been previously agreed by the army. The group ended up separated and the Turks took advantage, massacring 7,000 crusaders and slaying Louis's horse from beneath him.

Eventually reaching the port of Adalia, Louis abandoned his infantry because there simply weren't enough ships for them. Instead, he took only his wife and nobles aboard and set sail for Antioch.

Plague broke out in the crusader camp. Their fate was bleak – thousands were killed by the Turks – with thousands more taken into slavery.

On their eventual arrival in Antioch, Eleanor is said to have disgraced herself through inappropriate behaviour with her uncle, Raymond of Poitiers, the younger brother of her father. John of Salisbury, a contemporary chronicler, recorded thus:

> The most Christian king of the Franks reached Antioch, after the destruction of his armies in the east, and was nobly entertained there by Prince Raymond, brother of the late William, Count of Poitiers. He was as it happened the queen's uncle, and owed the king loyalty, affection and respect for many reasons. But … the attentions paid by the Prince to the Queen, and his constant, indeed almost continuous conversations with her, aroused the king's suspicions. They were greatly strengthened when the Queen wished to remain behind, although the king was preparing to leave, and the Prince made every effort to keep her, if the king would give his consent. And when the king made haste to tear her away, she mentioned their kinship, saying it was not lawful for them to remain together as man and wife, since they were related in the fourth and fifth degrees.[1]

To further Louis's humiliation, Eleanor refused to continue to Jerusalem. A furious Louis, dependant on the French vassals his wife brought along with them, had her arrested and forcibly taken with him to the Holy City. He assembled his army on 24 July and attacked Damascus, only to be roundly defeated after just four days. Par for the course, the presence of women in the crusade was blamed for the army's failure.

It had been a fruitless waste of life, and the majority of those who suffered were not great nobles, whose deaths were at least recorded for posterity with a degree of honour, but the nameless thousands who had pushed valiantly towards Jerusalem only to die anonymously in the dust.[2]

On their eventual return home, Eleanor and Louis were granted an annulment based on the grounds of consanguinity (being related by blood – they were third cousins once removed) in 1152; it was probably no coincidence that an annulment was pushed for, considering Eleanor had not provided a son and heir. The king retained custody of their daughters – and Eleanor has since been accused of all but abandoning them.

Within just two months, on 18 May 1152, she was married to Henry, Count of Anjou and Duke of Normandy in Poitiers at the cathedral of St Pierre. After the death of King Stephen of England on 25 October 1154, Henry was proclaimed king and Eleanor crowned queen beside him on 19 December at Westminster. From here on, her story quietens, and she took on a more ceremonial role.

Eleanor and Henry had eight children between 1152 and 1166. She was always moving, to keep up with her husband at their various courts and their respective activities of riding and sailing, and all the while invariably pregnant.

In 1165, Henry fell in love with Rosamund de Clifford *(see profile)* and embarked on a decade-long affair. Eleanor separated from Henry in 1167 and decamped to Poitiers, where for the first time she was able to fully immerse herself in the management of her own lands, from directing taxation, receiving homage from her lords at Niort, Limoges and Bayonne, and overseeing religious donations and tolls on products such as wheat, salt and wine.

While by accounts Henry was not a great father to their sons, Eleanor invested her time in securing a politically and dynastically suitable wife for her son Richard (*see Barangaria of Navarre*).

From 1174, she spent fifteen years imprisoned and isolated under house arrest in various locations, including Old Sarum in Wiltshire, on the orders of her now estranged husband Henry, for ruthlessly siding with their sons, led by 'Young Henry'. Wanting more power, in open rebellion against him the year before, Young Henry had fled to Aquitaine to plot against his father. That revolt, starting in 1173, ended in failure after eighteen months. During her confinement, it seems she was still kept in the manner to which she had been accustomed, with beautiful clothes for her and her household being delivered regularly from London. She, however, had to share a bed with her maid Amaria, and was given two additional servants to assist her.

An 1176 entry in the Pipe Rolls notes a payment of £28 13s 7d for two scarlet capes, two furs and a bedcover for the 'use of the queen and her servant',[3] suggesting that though Eleanor's living conditions were reasonable, they were not commensurate with her status, as her clothes were no finer than a servant girl's.

While Henry forgave his sons, he was slow to do the same for his wife. When Young Henry died in 1183 at the age of twenty-eighty, on his deathbed he begged for his mother's release; Henry II duly allowed Eleanor the freedom to return to England in 1184, but only under armed guard, to join the court for the main ceremonial events of the year, where she played her part as queen.

Eleanor was only fully released when Richard, her favourite son, ascended the throne in 1189. She ruled as regent in his name while he embarked on the Third Crusade. With her son John taking the throne on Richard's death in 1199, she spent time as an envoy to France before retiring as a nun to the abbey at Fontevraud and was buried there on her death in 1204.

Chapter 13

Rosamund de Clifford (c.1140 – c.1176) aka 'Fair Rosamund'

Running alongside the history of Eleanor of Aquitaine is that of Rosamund, the alleged mistress of Henry II of England – Eleanor's husband. There is limited factual knowledge of Rosamund – the rest is largely conjecture and legend. Although Henry had other affairs, his relationship with Rosamund endured from 1165, to her death in 1176 or 77.

What we do know is that she was probably born around 1140, one of at least six children, the daughter of a lord on the Welsh Marches (English counties such as Shropshire and Herefordshire that lie along the border with Wales), Walter de Clifford and Margaret de Tosny. Walter served Henry II on his campaign in Wales in the 1160s and perhaps the king met Rosamund at their family home Bredelais during that time.

Some say that the affair between Henry and Rosamund began around 1165, the first Christmas that he spent away from Eleanor, who was pregnant with their last child, John, who would be born Christmas of 1166. Humiliating in the extreme, there is a story that Eleanor wanted to have her baby at the royal palace of Woodstock and arrived only to find Rosamund already installed. She removed herself to Oxford to give birth instead.[1]

In 1174, Eleanor was sent to Old Sarum, where she was imprisoned for fifteen years after siding with her sons John and Richard in a

rebellion against Henry. Richard freed her when he ascended the throne in 1189. Perhaps not coincidentally, while Eleanor was imprisoned, Rosamund's relationship with the king was openly acknowledged and it's likely she travelled with him as part of his entourage.

She lived at the royal palace (more of a comfortable hunting lodge) of Woodstock in Oxfordshire. Before their affair was made public in 1174, romantic rumour has it there was a secret labyrinth through which Henry would go to meet her and a hidden bower for their trysts. 'Rosamund's Well' still exists in the grounds of present-day Blenheim Palace.

Chroniclers of the time weren't kind to her, painting her as a fallen woman and adulteress. Several puns on her name were created, including 'rosa immunda', or 'unclean rose', instead of the accurate 'rosa mundi', meaning 'rose of the world', and rosa immundi, the 'unchaste' rose.

Around 1175, she moved to Godstow Abbey, where her mother was buried; it is thought she was already unwell before she died in 1176, roughly at the age of thirty. Her death gave rise to gossip that foul play, usually instigated by Eleanor, was involved, ranging from stabbing her in the bath to successfully poisoning her. (The story of her alleged poisoning first appears in the French Chronicle of London in the fourteenth century).

It's rumoured that Henry paid for her extravagant tomb within Godstow, a twelfth-century Benedictine nunnery, in front of the high altar. Henry went on to endow the convent with two churches at Wycombe and Bloxham. Rosamund's father, Walter, granted the abbey mills and a meadow, for the souls of his wife and daughter. Even in death, Rosamund was treated with disdain; in 1190 Bishop Hugh of Lincoln, seeing that her remains had been given a place of

honour within the church at Godstow, insisted that they be removed to the nuns' chapter house, with a tongue-lashing of an inscription:

This tomb doth here enclose the world's most beauteous Rose, Rose passing sweet erewhile, now nought but odour vile.[2]

Centuries after her death, sixteenth-century German traveller Paul Hentzner describes what he saw while visiting her tomb:

Not far from this palace [Woodstock] are to be seen near a spring of the brightest water, the ruins of the habitation of Rosamund Clifford whose exquisite beauty so entirely captivated the heart of King Henry II that he lost the thought of all other women. She is said to be poisoned at last by the queen. All that remains of her tomb of stone, the letters of which are almost all worn out, is the line,

Adorent, utque tibi detur requies Rosamunda precamur.
[Let them adore... and we pray that rest be given to you, Rosamund.][3]

Charles Dickens wrote about Rosamund in his *Child's History of England* (1851–53):

There was a fair Rosamond, and she was (I dare say) the loveliest girl in all the world, and the king was certainly very fond of her, and the bad Queen Eleanor was certainly made jealous. But I am afraid – I say afraid, because I like the story so much – that there was no bower, no labyrinth, no silken clue, no dagger, no poison. I am afraid Fair Rosamond retired to a nunnery near Oxford, and died there, peaceably.[4]

Chapter 14

Margaret of Beverley (Margaret of Jerusalem) (1150–1214)

Margaret fought the Saracens in Jerusalem and is likely to have been the first woman crusader to have experienced direct military action. She was born in the kingdom of Jerusalem while her Christian parents Sibilla and Hulno were on pilgrimage. Making the arduous journey across Europe during Sibilla's pregnancy was clearly the devoted actions of a profoundly devout family.

On the family's eventual return to England, she spent her early years in the market town of Beverley, East Yorkshire. Following the death of her parents, from around the age of 11 she raised and educated her younger brother Thomas, who would go on to become a monk and her biographer. His account of her life still exists: 'Hodoeporicon et percale Margarite Iherosolimitane' in a scholarly edition.

Having settled Thomas in school, Margaret returned to the Holy Land, the place of her birth, in the mid-1180s and was in Jerusalem in 1187 just before Saladin, the Muslim sultan of Egypt and Syria, famously laid siege for fifteen days, defeating a huge army of Crusaders at the Battle of Hattin. The city fell on 2 October of that year.

The scene was catastrophic; besieged with no food or water in scorching temperatures. Jerusalem, not only surrounded by enemy forces, also contained refugees from other cities defeated by the Saracens, such as Acre, Beirut and Jaffa. Women, including Margaret,

who had no choice but to stay, played their part in the fight, using weapons and catapults and providing desperately needed sustenance.

Margaret refused to run or hide, choosing instead to fight alongside the crusaders. Thomas records her account of the siege:

[L]ike a fierce virago, I tried to play the role of a man, … During this siege, which lasted 15 days, I carried out all of the functions of a soldier that I could. I wore a breastplate like a man; I came and went on the ramparts, with a cauldron on my head for a helmet. Though a woman, I seemed a warrior, I threw the weapon; though filled with fear, I learned to conceal my weakness.[1]

Note: the cooking pot as a helmet may well have been an editorial embellishment by her brother. She was wounded when 'a millwheel fell near me; I was hit by one of its fragments; my blood ran… the scar remains.'[2]

She was captured soon after the siege by Saladin's army and spent the next fifteen months, between October 1187 and February 1189, as a slave: 'I was forced to carry out humiliating tasks; I gathered stones, I chopped wood. If I refused to obey, I was beaten with rods.'[3]On her eventual release, (thanks to the generosity of a Christian merchant from Tyre who additionally paid for the release of twenty-four of her fellow slaves), Margaret continued her pilgrimage:

avoiding the towns and public places. In the fear of being captured, I walked always in hiding. I was garbed only in a sack that I had worn when captive: it was short and light, without colour or warmth; it scarcely covered my nudity.[4]

Her sole possession was her Psalter. Barely surviving, one loaf of bread and scavenged plant roots kept her alive for five days. She went

to Antioch, only to find herself once more in a city under siege by Saladin, found work as a washer woman and gave fervent thanks for her existence at the shrine of her namesake, St Margaret.

In July 1188, a Muslim army arrived in Antioch and engaged in fighting with the Christians. Margaret was accused of stealing a knife; it was also believed she had been plundering treasure from the dead in previous battles, the Saracens identifying trinkets she had allegedly taken as their proof.

Ignorant of their language and unable to express herself or her innocence in Turkish, a desperate Margaret invoked the name of the Virgin Mary; moved by her piousness, the army released her, allowing her to embark on her return journey to England thanks to an 1192 treaty between the Sultan and Richard the Lionheart.

On the way home alongside other English crusaders, she continued her pilgrimage of fervent thanks, visiting shrines at Acre, Rome and Santiago de Compostela in Spain, before reaching the French border and discovering that her brother Thomas resided at a monastery in France. It had been years, perhaps a decade, since they last saw each other and Margaret had to prove who she was to her stunned younger sibling, who burst into tears of emotion at their reunion. She recounted her adventures, and he dutifully recorded them, advising her to join the convent of Montreuil-sous-Laon not far from his own monastery.

She spent her remaining years as a nun, dying around 1214/1215. Her brother only published his book after her death, as his own personal tribute and elegy to her.

Chapter 15

Sibylla of Jerusalem (1160 – 1190)

During the 200 years of the existence of the kingdom of Jerusalem, most of its queens were of Armenian descent. Sibylla, the granddaughter of Melisende of Jerusalem, was Countess of Jaffa and Ascalon from 1176 and queen of Jerusalem from 1186 to 1190. The modern world has been made more aware of her through the actress Eva Green playing her character in the film 'Kingdom of Heaven'.

Sibylla was the eldest child of King Amalric (king of Jerusalem between 1163 and 1174), and Agnes de Courtenay, whose family lands in Odessa (the most northern of the Crusader states) had been lost to the Saracens. Her brother was King Baldwin IV, (who ruled between 1174 and 1185).

The Court of Jerusalem declared the union of Amalric and Agnes invalid because they were third cousins, too close for the church's comfort. The Court also claimed Agnes was a bigamist and had been married before. For Amalric to be crowned king and his son to be named heir, he would have to renounce his own wife and annul their marriage.

Although these facts were 'suddenly' discovered a few years into the marriage, Almaric was forced to act out of political expediency. It's likely that the Court was worried that Agnes and her family, now landless, would stake a claim to the kingdom of Jerusalem.

Agnes was banished from court when Sibylla was three years old. Sibylla was then also sent away, to be raised at the Convent of St

Lazarus by her father's aunt – the Abbess Ioveta of Bethany (sister of Melisende, the former queen of Jerusalem who had founded the convent for Ioveta in 1128).

Sibylla's brother Baldwin (later known as Baldwin the Leper) remained at court to learn the ways of the kingdom. Her half-sister was Isabella I, Queen of Jerusalem between1190 and 1205.

Almaric died in 1174, when Sibylla was fourteen, and her brother Baldwin became king at the age of thirteen. Baldwin IV was diagnosed with leprosy at the age of nine. It was his tutor, historian William of Tyre, who first noticed the symptoms. Baldwin had been playing with his friends and complained of a complete lack of feeling in his right arm and felt no pain even if pinched or bitten. Under normal circumstances, a diagnosis of leprosy would turn the sufferer into a social pariah – as well as condemn them to almost certain death. Baldwin IV, however, was intelligent, with a quick mind and a gifted rider.

Baldwin's leprosy meant that he would leave his kingdom childless, and this made Sibylla a person of great interest to the court. It became imperative for the longevity and security of the kingdom that the right husband was chosen for her – someone with military skill who could lead the kingdom's armies and defend it against the growing threat of the Saracens.

Stephen of Sancerre of the House of Blois came to court to pay his addresses to her. Stephen's sister was married to Louis VII of France. He confounded expectations, and likely completely humiliated Sibylla, by refusing to marry her and abruptly leaving court.

The reasons are lost to history – but perhaps he didn't like Jerusalem, or the fact that Saladin's increasing rise in power would pose a huge potential future threat, one that he didn't relish facing.

In late 1176, Sibylla was eventually married to William Longsword of Montferrat, eldest son of the Marquess William V of Montferrat,

and a cousin of Louis VII of France. He was made Count of Jaffa and Ascalon, in keeping with the traditional honour given to an heir apparent.

William died just a year later, possibly from malaria, leaving the seventeen-year-old Sibylla a pregnant widow. She subsequently gave birth to a son and, continuing the family tradition, named him Baldwin. Noblemen moved quickly to try and use her position for their own political gain. The Count of Flanders demanded the right to choose her next husband. He put forward names that were undeniably biased towards his own gain; they were summarily rejected.

Next to show interest was Baldwin of Ibelin, Lord of Ramla and Mirabel. Then Hugh, Duke of Burgundy. Neither came to fruition, because in 1180, an infatuated Sibylla decided to marry Guy de Lusignan, a vassal of Henry II. Together they'd have two daughters, Alice and Maria, who would die of plague in Acre in September/ October 1190.

Within a couple of years, Sibylla's brother, Baldwin IV, was desperate to annul her marriage, but failed. He didn't like his brother-in-law or trust his abilities or intentions. Before his death in 1185, and in a last-ditch effort to keep Guy off the throne, Baldwin crowned Sibyl's six-year-old son from her first marriage as Baldwin V. The child died just a year later in 1186.

Sibylla, playing a superb game of political chess, persuaded the high-ranking religious official Patriarch Heraclius to crown her, promising she would annul her marriage to Guy and choose another king. The Court agreed. She kept her word, divorcing Guy, only to marry him again and make him king. Ultimately, her adoration and loyalty to Guy would result in the downfall of her kingdom.

War broke out with Saladin, the Sultan of Egypt and Syria, with the city of Tiberiade (Tiberias) on the sea of Galilee falling to him in 1187. Crusader knight Reynald of Chatillon (l.c.1125–1187 CE)

had attacked a Muslim caravan on a holy haj, or pilgrimage, from Damascus in clear violation of an 1185 peace treaty. Not only that, he took Saladin's own sister as prisoner, mocked the Prophet Muhammad and tortured his prisoners. Saladin was utterly outraged and vowed a gruesome revenge.

Guy had resolved to reclaim Tiberias but his Frankish troops (the name given to the Crusader settlers by their enemies), numbering over 16,000 were defeated at Hattin, where Saladin had around 12,000 mercenaries and up to another 12,000 conscripted soldiers.

A particular tactic of the Muslim army was attacking the horses of the Crusader soldiers rather than trying to penetrate their intense armour. Thirteenth-century Arab historian Abu Shama states:

A Frankish knight, as long as his horse was in good condition, could not be knocked down. Covered with mail from head to foot, which made him look like a block of iron, the most violent blows make no impression on him. But once his horse was killed, the knight was thrown and taken prisoner. Consequently, though we counted them [Frankish prisoners] by the thousand, there were no horse among the spoils whereas the knights were unhurt.[1]

Count Raymond III of Tripoli (a coastal crusader state spanning what's now northern Lebanon and western Syria) deserted the battle, charging towards Saladin's forces, only to be allowed to pass through safely, in what many believe was a pre-orchestrated escape plan (Raymond had been regent to Baldwin the Leper). Guy 'led the army across the baking-hot Galilean hills for a day until, harassed by Saladin's troops, overwhelmed by scorching heat, and paralysed by thirst, he pitched camp on the volcanic plateau of the twin-peaked Horns of Hattin. They then went looking for water – but the well

there was dry. 'Ah Lord God', said Raymond (of Tripoli, whose wife was besieged in Tiberias), 'the war is over; we are dead men; the kingdom is finished.'[2]

In a further historical twist, Raymond's besieged wife was the princess Lady Eschiva of Tiberias (1135–1187) and in 2017, archaeologists discovered the tunnel she likely used to flee Saladin's forces. Eschiva was Princess of Galilee from 1158 to 1187 and Countess of Tripoli from 1174 to 1187. She was the daughter of Prince William I of Bures and Ermengarde of Ibelin. The House of Ibelin was a noble family in the Crusader kingdom of Jerusalem in the twelfth century. She married Count Walter of Saint Omer in 1158, becoming Princess of Galilee. It was Baldwin III of Jerusalem who arranged the marriage. When Walter died in 1174, leaving Eschiva with two sons, Hugh II and Raoul of Saint Omer, she went on to marry Count Raymond III of Tripoli.

The tunnel, built of basalt stones, was discovered close to the Old City and linked the citadel to the harbour of Tiberias. Archaeologists also found artefacts including several pipes for smoking. It's thought Eschiva fled to the lake through the tunnel, but once she realised the help promised by her husband wasn't forthcoming, she had no choice but to return to city. On 5 July 1187, she surrendered the fortress.

Guy and some of his nobles were captured and released only when he ceded the port of modern-day Ashkelon. Sibylla, trapped in Jerusalem in September of 1187, asked Saladin to allow her to be joined in captivity with her husband. It fell to her former brother-in-law, Conrad de Montferrat, the younger brother of her first husband, and the Baron of Ibelin, to salvage what remained of Jerusalem.

Still she remained loyal to Guy; at his eventual release, she stood by his side at the siege of Acre, while in turn Saladin's forces surrounded them, cutting off all their supplies except those accessible by sea.

Conditions were described as nothing short of dDeplorable',
including 'acute hunger at times and, eventually, disease'.[3]

And yet she remained more devoted to Guy than her role as
crowned queen of Jerusalem. This misplaced loyalty sealed her fate;
together with her two children with Guy, she died of fever 'in the
squalor of the siege camp before Acre in 1190'. She was just thirty
years old.

Saladin spent over twenty years fighting the Crusaders before
Jerusalem eventually fell to him on 2 October 1187. This victory
(with Saladin's forces being less violent and bloodthirsty than the
Crusaders themselves during the First Crusade) ultimately was the
end of the Crusader States in the Middle East and led to the mostly
unsuccessful Third Crusade of 1189-1192.

Chapter 16

Berengaria of Navarre (1165–1230)

Queen Consort to Richard I, Berengaria (meaning bear-spear) is the only queen of England to never have stepped a royal foot on English soil.

Her exact date of birth is unknown; one of seven children, Berengaria was the daughter of King Sancho VI of Navarre (Sancho the Wise or 'Sancho el Sabio'), and Sancha of Castile (the daughter of the king of Castile and his wife, a princess of Aragon). She was also a descendant of Spanish national hero Rodrigo Díaz de Vivar, known as El Cid.

Navarre was a Spanish kingdom, dominated by neighbouring Aragon, Leon and Castile. Her mother died when Berengaria (named after her grandmother, Berengaria of Barcelona) was fourteen years old. Sancho, who had acceded the throne at the age of eighteen, fought to retain the independence of his kingdom from his larger neighbours and would never remarry.

Berengaria lived her life as a political pawn; she was useful for a short time to her husband, Richard the Lionheart (ruling between 1189 and 1199, leader of the Third Crusade) and his powerful mother Eleanor of Aquitaine, and then discarded when deemed surplus to requirements.

After they first met in the spring of 1191, it was Eleanor who brought Berengaria from the palace of Olite in Navarre to Sicily to meet her future husband, a journey of around 1,585 miles. By all accounts, the relationship between Eleanor and Berengaria was frosty. The latter

may have been attractive, intelligent and virtuous, but to the mighty Eleanor, she seemed to lack any fire or spirit. Unlike Eleanor, she was:

> a passive female who would allow herself to be buffeted by the winds of circumstance and never raise a finger in her own behalf. No doubt overawed at the prospect of becoming Coeur de Lion's queen, she delivered herself into Eleanor's hands like a lamb being carried to slaughter.[1]

They should have met Richard in Marseilles, but when they arrived, he had already left for Sicily, en route to support his sister Joanna following the death of her husband, King William II of Sicily. His passing had opened a power vacuum and an unscrupulous illegitimate nephew, Tancred of Lecce, was trying to usurp the throne, stealing her dowry and throwing Joanna into a Palermo prison in his attempt to do so. (Tancred eventually capitulated in the face of Richard's wrath, giving him 40,000 ounces of gold towards the Crusade.)

They eventually reached Sicily on 31 March 1191, but because they arrived on the eve of Lent, when marriages were prohibited, Richard and Berengaria were not allowed to sail together. Richard put his wife-to-be and his sister on one of a number of transporter ships to the Holy Land, more commonly known as 'busses'. After two weeks at sea, they arrived at Limassol, Cyprus, bang in the middle of fierce battles between the crews of English ships who had docked there to resupply or been shipwrecked. Eleanor and Berengaria were extremely nervous to step off the ship in case Cyprus's ruler, Isaac Komnenos, took them prisoner.

Their fears were well founded; Komnenos took them prisoner and demanded a hefty ransom from Richard. The Lionheart landed at Limassol on 6 May and was furious. Despite Isaac having been described by one English chronicler as a 'tyrant', who had allegedly

made a blood pact of friendship with Saladin, Richard launched a brutal fifteen-day military campaign, which he won triumphantly. He seized Isaac and his favourite daughter, with the former imprisoned for life, and seized control of Cyprus entire.

While no doubt outraged for the honour of his sister and bride-to-be, Richard used the women as his excuse – it's likely he had always planned to invade because he had wanted Cyprus to hold supplies for his Crusade. The Cypriot princess was taken hostage.

After swiftly conquering Cyprus by displaying the military prowess for which he became well known, Richard promptly sold it on to the Knights Templar, who in turn sold it on again to the exiled Guy of Lusignnan, the king of Jerusalem defeated at Hattin.

Berengaria and Richard were married on 12 May 1191, at the Chapel of St George at Limassol on Cyprus. The ceremony was performed by Richard's chaplain Nicholas, who later became the Bishop of Le Mans. Richard wore a rose silk tunic with a scarlet cap, gold embroidered cape and sash and a gold and silver scabbard. Berengaria's outfit is not recorded.[2]

Berengaria was crowned queen of England the same day by the Archbishop of Bordeaux and Bishops of Évreux and Bayonne. It was entirely a marriage of political expediency. On marrying Richard, Berengaria became queen of England, queen of Cyprus, Duchess of Normandy, First Lady of Brittany, Countess in waiting of Aquitaine, Countess of Poitiers, Anjou, Nantes and Maine and owner of the town of Le Mans.

The practical work of marriage done, Richard was ready to sail for the Holy Land from Famagusta, which he did on 7 June 1191, to the siege of Acre. His sister and new wife had already departed ahead of him on board transport ships. Having completed her part in marrying off her son, Eleanor moved to the next item on her agenda; she aimed

for England, to ensure her younger son John was not causing any additional trouble to his own throne.

Richard and Berengaria had three weeks together on the island of Aphrodite before he set off on the Third Crusade with a fleet of 219 ships. Berengaria arrived in Acre in June and spent the next two years living there, and in Ramleh and Jaffa, with her sister-in-law, and the Cypriot princess, while Richard fought the 'Infidel' under the banner of Christ.

It wasn't much of an existence – too dangerous to travel or sightsee, the women's time would have been highly limited to prayer, embroidery, reading and weaving. Berengaria has been described at this time as being 'in a curious limbo with no outlet for any of the traditional activities associated with her position.'[3]

Together their day-to-day existence was very limited – and in many ways it had to be. Ever conscious of wider perceptions of Eleanor's reputation as a crusader, Berengaria was mindful of being discreet so as not to invite further criticism. Indeed, such were her efforts that "the silence of the chroniclers about Berengaria and Joanna suggests that their conduct was spotless: their lives were apparently so dull that there was nothing worth recording of them."[4]

In 1192, when it became clear that the Crusaders wouldn't claim Jerusalem, Richard and Saladin reached an agreement to end the Crusade. It was decided the best course of action was to send Berengaria and Joanna back to England. They set sail from Acre in September that same year, landing in Brindisi, a port city in south-eastern Italy, before Berengaria continued to Rome where she spent six months.

She then received the news that her husband had been kidnapped outside of Vienna and was being ransomed by the Holy Roman Emperor for 100,000 marks. Side-lined once again, it was Eleanor

of Aquitaine who moved heaven and earth to raise the money in an attempt to ensure her other son John didn't seize the throne.

Berengaria was rendered politically impotent. It's largely believed she was not involved in securing his release; however, while in Rome, she did put her signature, 'Queen of the English, Duchess of the Normans and Amuitainians, Countess of the Angevins', on a charter securing a loan.[5]

It's possible that this attempt to raise money was connected to Richard's imprisonment. She spent two happy years with her own family, likely experiencing a sense of freedom and independence denied to her during her time alongside her husband.

It speaks volumes for the argument that she wasn't close to her husband, that she failed to go to England; indeed, she wasn't even in England to welcome Richard home when he was finally released in 1194. The couple were not reunited until the summer of 1194. Berengaria brought her brother Sancho with her, and some biographers speculate that Richard was more interested in him than his own wife. Husband and wife witnessed Joanna remarrying, to the Count of Toulouse; by all accounts it was an extremely unhappy relationship.

It's uncertain whether the marriage between Richard and Berengaria was ever consummated; the couple never had any children, whether due to fertility issues, because they were separated for long periods of time or because rumours about Richard's sexuality were true.

In 1195, the couple bought some land at Thoree and built a home there. There is, however, no evidence that they actually lived there together and nothing of the house, or its mill and fishpond, survive, although we do know that in 1216 Berengaria gifted it to the Brothers of the Hospital of Jerusalem.

Richard was wounded in the spring of 1199 and died in Aquitaine on 6 April. His mother Eleanor was at his deathbed, not his wife, and

Berengaria did not attend his funeral. In Eleanor's eyes, Berengaria had served her short-lived purpose.

Berengaria was left to fight for the right to her original lands, as well as those left to her by Eleanor. Richard's brother John never returned them to her, leaving Berengaria verging on destitute for much of her later life. After an unhappy marriage, John and Eleanor made it quite clear on her becoming a widow that they weren't too concerned with her wellbeing.

In 1229, she founded the abbey of L'Espau and ruled the city of Le Mans and its thirty-seven parishes, in the city of Maine, which was eventually given to her by Philip Augustus. From now on, she wouldn't use any of the titles, simply signing herself '*humilissima regina quondam Anglo-rum*' – 'most humble former queen of the English.'

In Le Mans, she earned a reputation for persecuting the local Jewish population. As in England, Jews were allowed to be moneylenders. Berengaria had hired many during her marriage. It was perfectly legal for the homes and properties of Jewish residents to be confiscated, without them being financially compensated. All this, despite the actions being banned in a Papal Bull of 1120. Berengaria took advantage of the 'nothing to see here' approach and gave a servant known only as 'Martin' a house and vineyard confiscated from two Jewish owners called Desire and Copin in 1208. She also profited from the sale of land by converted Jews and gave a former Jewish school building to her chapel.

In 1216 she removed the city's synagogue; a stained-glass window dating from the twelfth century which depicts the Jewish house of prayer can be seen in the cathedral of Le Mans. The Jews were expelled in 1289, at the same time as those of Maine and Anjou.

Berengaria died in December 1230. She was buried at the abbey at L'Espau; Richard's family refused to allow her to be buried alongside him at Fontevraud Abbey.

Chapter 17

Licoricia of Winchester
(early thirteenth century – 1277)

Described by historian Robert Stacey as 'the most important Jewish woman in medieval England', Licoricia was a prominent English businesswoman, moneylender and friend of King Henry III and his queen Eleanor. Her clients included prominent members of the royal court.

We don't know when or where Licoricia was born, but that she lived during a time of fearsome anti-Semitism. History first notes her in 1234 as a young widow in Winchester with at least three sons and a daughter and running her own moneylending business. Jews were deemed to be property of the crown, and as such were subject to both protection and heavy taxation.

And therein lies the rub; there are tantalisingly few pieces of evidence for historians to pull together the life of this fascinating medieval Jewish woman. While the Jews of England made up just 0.25 per cent of the population at the end of the twelfth century, they provided a staggering 8 per cent of the royal treasury's total income. The church viewed moneylending (or the usury or interest it accrued) as a sin and the Pope declared it a forbidden vocation for Christians.

1130 marks the year that a Jewish loan was first recorded, to the earl of Chester and the Clare family. Thomas Beckett borrowed 500 marks in 1159 to pay his soldiers when he was chancellor and even Henry II used them "exclusively for his own private financial needs."[1]

Daughter of Isaac, Licoricia (whose name means 'sweetmeat') was born at the end of the thirteenth century. She was married twice and sent to the Tower of London twice. Her first husband was Abraham of variously Kent and Winchester; her second husband was a prominent banker simply known as 'David of Oxford'. When David died in 1244, just two years after they wed, Henry III imprisoned her in the Tower to ensure she didn't interfere in official financial assessments of her late husband's estate. (It's estimated that the crown would take one-third of deceased Jews' property as a death duty.) Some of that money, including an additional 5,000 marks added on top of the already hefty duty, contributed to the building of Westminster Abbey and Lincoln Cathedral.

A surprisingly good relationship with the king developed, with Henry backing Licoricia's efforts to reclaim debts and giving her an exemption from additional taxes. His protection of her meant that her business influence expanded, and she lent money not just to the noble court and royal family, but to members of the church, fellow Jews, farmers, and landowners.

In 1258, Licoricia found herself back in the Tower after a neighbour falsely accused her of stealing a ring meant for the king; investigations proved that the accuser was in fact the guilty party and Licoricia was released.

In 1277 she was found by her daughter Belia, stabbed to death alongside her Christian maid, Alice of Bickton, and the sum of £10,000 stolen, in what appeared to be a robbery at her Winchester home. Her reputation was such, that her death was reported to the Jewish community in Germany. 'She was Jewish, she was rich [and] she was a woman. All three might have led to her death'.[2]

While three suspects were initially arrested on suspicion of a burglary or business deal gone awry, they were released without charge. Instead, a saddler who had left the city was accused. Licoricia's

sons tried and failed to bring a new case against the three men and her murder has never been solved.

Her son Benedict became the only Jewish guildsman in medieval Britain, before his own execution in 1279. With the flames of anti-Semitism fanned by the Crusades, false allegations of the 'blood libel' trope and general financial upheaval meant that all of England's Jews were expelled in 1290 on the orders of King Edward I.

The 'blood libel' refers to a centuries-old false allegation that Jews murder Christians – especially Christian children – to use their blood for ritual purposes, such as an ingredient in the baking of Passover matzah (unleavened bread). It dates to the Middle Ages and has persisted, despite official repudiations by the Catholic Church. Blood libels have frequently led to mob violence and pogroms and have occasionally led to the decimation of entire Jewish communities.

Licoricia's story illustrates the prosperity and then decline of the Jewish community; one of her sons was hanged for 'coin clipping' and counterfeiting during November 1278 when the entire Jewish population of England (around 3,000) were subject to arrest and search on suspicion of the crime. Ultimately, 680 Jews were sent to prison at the Tower and more than 300 were executed in 1279. Another son was banished when the king expelled the entire Jewish populace from the country.

Following a five-year campaign, a 6ft tall bronze sculpture of Licoricia by Ian Rank-Broadley was unveiled in Winchester on 10 February 2022 by HRH Prince Charles and the Chief Rabbi of the United Kingdom, Ephraim Mirvis. It is thought to be the first, if not one of very few, public sculptures of Jewish women. It features her son Asser and is situated in Jewry Street, where the Jewish community was historically based. No images of her survive, so Ian based the subjects features on his own daughter and grandson.

Chapter 18

Philippa of Hainault (1314–15 August 1369)

Queen Consort of England as the wife of King Edward III, Philippa was the daughter of William III the Good of Hainault and Joan of Valois. She was also the granddaughter of Philip III, king of France, one of eight siblings and the second of five daughters.

Of Moorish ancestry and from Hainault, a province in modern-day Belgium known for its textile industry, she is remembered as possibly the first black queen of England.

Bishop Stapledon of Exeter, an English ambassador, went to visit the eight-year-old princess at the Hainault court. He duly reported back on her suitability as a potential wife for King Edward II's son, Prince Edward, although it's unclear whether his report refers to Philippa's older sister Margaret:

The lady whom we saw has not uncomely hair, betwixt blue-black and brown. Her head is clean-shaped; her forehead high and broad, and standing somewhat forward. Her face narrows between the eyes, and the lower part of her face is still more narrow and slender than the forehead. Her eyes are blackish-brown and deep. Her nose is fairly smooth and even, save that it is somewhat broad at the tip and somewhat flattened, yet it is no snub-nose. Her nostrils are also broad, her mouth fairly wide. Her lips somewhat full, and especially the lower lip. Her teeth which are fallen and grown again are white enough, but

the rest are not so white. The lower teeth project a little beyond the upper; yet this is but little seen. Her ears and chin are comely enough. Her neck, shoulders, and all her body and lower limbs are reasonably well shapen; all her limbs are well set and unmaimed; and nought is amiss so far as a man may see. Moreover, she is brown of skin all over, and much like her father; and in all things she is pleasant enough, as it seems to us. And the damsel will be of the age of nine years on St John's day next to come, as her mother saith. She is neither too tall nor too short for such an age; she is of fair carriage.[1]

Curious that depictions of her show a traditionally fair English maiden rather than honouring her likely darker skin and heritage. She and her husband-to-be were cousins – (both were grandchildren of Philip II of France through their mothers). Their marriage was, as typical of the time, a business and military transaction.

In an agreement with Willem, Count of Hainault, Philippa's hand in marriage and destiny as a queen consort of England, was given in return for financial and military support to Edward's mother, Queen Isabella of France, the estranged wife of Edward II, who was determined to overthrow her husband and his hated chamberlain, (and rumoured lover) Hugh Despenser the Younger.

Within a few months of the agreement, Isabella, supported by Marcher Lord Roger Mortimer (her lover), had invaded England, forced her estranged husband Edward to abdicate, and became widowed after he mysteriously died in custody.

Another three months after that unfortunate incident, Philippa of Hainault arrived in England on 23 December 1327, and on 24 January 1328, married the new King Edward III at York Minster. (Their marriage contract recently sold at auction for £150,000).

It wasn't an easy first few years; Philippa's mother-in-law Isabella was powerful and not about to hand over either the reigns or limelight to her new fourteen-year-old daughter-in-law. This point is underscored by the fact that Philippa wasn't crowned for a further two years – on 4 March 1330 at Westminster Abbey, when she was six months pregnant.

Their first child, Edward of Woodstock, later known as the Black Prince, was born on 15 June 1330, nine days before Philippa's sixteenth birthday.

It was after the birth of this first son that Edward III got serious about his kingship. The production of an heir gave him the confidence to stage his own coup and overthrow both his mother and Mortimer, who was brutally executed.

Philippa was a much gentler figure at court than her mother-in-law and is said to have been particularly patient about her husband's affairs. They had at least twelve children: seven sons (of which only five survived) and five daughters:

Edward, Prince of Wales – the Black Prince (15 June 1330–1376)
Lionel, Duke of Clarence (29 November 1338–1368)
John, Duke of Lancaster (John of Gaunt) (6 March 1340–1399) All English monarchs from Henry IV are his descendants.
Edmund of Langley, Duke of York (June 1341–1402)
Thomas of Woodstock, Duke of Gloucester (1355–1397)

Another three sons and two daughters died in infancy.

- Isabella Plantagenet (6 June 1332–1379)
- Joanna/Joan Plantagenet (1334–1348, died of the Black Death)
- Mary Plantagenet (10 October 1344–1362)
- Margaret Plantagenet (1346–1361)

The rivalry of those sons would bring about the great civil war, the Wars of the Roses.

Philippa acted as regent for her husband in 1346 during the Hundred Years War between England and France. She convinced Edward to spare the lives of the local Calais townspeople after the Siege of Calais in 1347.

She also rallied the English troops in 1346 to fight against a Scottish invasion, leading to the capture of King David II.

Phillipa encouraged entrepreneurship, inviting Flemish weavers to move to England and practice in Norwich; she was the patron of St Katherine's hospital near the Tower of London and established the Queen's College at Oxford University in 1341.

Alice Perrers joined the royal court as a lady in waiting to Philippa in 1362 and despite the apparent devotion between husband and wife, Alice became Edward's mistress by the following year. (*See the chapter on Alice Perrers for more.*) While initially handled discreetly, there would be a marked difference between the respect in which Philippa was held by the court and the disgust levelled at Alice.

In 1358, Philippa had an accident, falling from her horse, breaking her shoulder blade; the incident caused her considerable discomfort for the remaining eleven years of her life. She died on 15 August 1369 at Windsor Castle at the age of fifty-five from dropsy (swelling and heart failure). On her deathbed, she is said to have made three requests of Edward: to pay any merchants she had bought goods from, fulfil all her financial promises to her servants and the church, and that at his own death, he would be buried beside her at Westminster Abbey. Tearfully, he said he would.

Philippa was buried in Westminster Abbey on 9 January 1370 and was described by St Albans chronicler Thomas Walsingham as 'the most noble woman'.

Philippa's legacy is remarkable not only by her descendants but by the practical example of queenship she established, a template that would be observed by those who followed her. She was, in many ways, the ideal medieval consort.

Chapter 19

Julian of Norwich (1342 – c.1416)

Just because I am a woman, must I therefore believe that I must not tell you about the goodness of God, when I saw at the same time both his goodness and his wish that it should be known?[1]

Fourteenth-century theologian, famous mystic and contemporary of Chaucer, it's unclear whether her name was 'Julian', or whether she became known for the saint's name of the parish church in which she served. Also known as Dame Julian, Mother Julian or Juliana, she lived through two waves of the Black Death, (1348–50) and (1361–62).

The earliest reference to an anchorite in Norwich named Julian occur in a will dating from 1394; her anchorhold is later identified as besides St Julian's church in another will from 1404. She was born in 1342 to a well-off family and educated at a boarding school attached to Carrow Abbey nunnery.

On 8 May 1373, when she was about thirty years old, gravely ill and on her deathbed receiving the last rites, she received fifteen divine revelations or 'shewings' from Jesus Christ. One of them she describes thus:

And in this vision he also showed me a little thing, the size of a hazelnut, lying in the palm of my hand, as it seemed to me, and it was round as a ball. I looked at it with my mind's eye and

thought, 'What can this be?' And the answer came in a general way, like this: 'It is all that is made.'[2]

It was this experience which drove her to become an 'anchoress'. Of her own free will, she chose to be walled into a cell or anchorhold, completely cut off from society, to live a devout life of prayer and contemplation.

She had no way of getting out of her 12-foot square quarters, attached to the parish church of St Julian at Conisford in Norwich, Norfolk, which during the Middle Ages was a bustling city, second in size only to London, with a strong trade in wool and the associated wealth to build many churches.

Food and drink were brought to and from her cell by dedicated attendants, and through the two or three small windows of her cell, she would offer religious advice and support to locals and visitors.

Perhaps incomprehensible in the modern age, during the medieval era it was an accepted and even popular way of living one's life. According to the British Library, there were around 100 anchoresses during the twelfth century, often giving out spiritual advice to their communities. Records also show that there were 214 anchorites during the fourteenth century.

The word 'anchoress', or 'anchorite' for a man, is derived from the Greek word 'anachoreo', which means 'to withdraw'. Their seclusion and devout prayer enabled them to embody the Christian values of stability, obedience, poverty and chastity. The symbolism of their being dead to the world was demonstrated by a priest who recited the office of the dead when the anchoress was sealed in her enclosure. Some remained entombed, literally, after their actual deaths.

Archaeologist excavations at St. Anne's church in Lewes, Sussex discovered that the grave of the anchoress was in the exact spot she

would have been kneeling on a daily basis to watch the Mass through the 'squint'.

Julian is author of *The Revelations of Divine Love*, the earliest surviving book in the English language to be written by a woman. It includes accounts of further revelations she experienced during her lifetime. It is also the only text written by an anchoress during the time to have survived. Phrases such as 'All Shall Be Well, and All Shall Be Well', are directly attributed to her.

She was visited by the mystic Margery Kempe in 1413. The meeting was described as follows:

> Then she was charged by our Lord to go to an anchoress in the same city who was called Dame Julian. And so she did and [she] showed her the grace that God had put in her soul… and many full speeches and conversations that our Lord spoke to her soul, and many wonderful revelations which she revealed to the anchoress in order to establish if there was any deception in them, for the anchoress was an expert in such things and could give good counsel on the matter.[3]

Julian spent two decades revising, refining and honing the descriptions of her visions into what we know as the 'Long Text'. It is the rigorous efforts of future women writers, including exiled seventeenth-century nuns from France and Belgium, that ensured her work survived. Challenging the 'imbalance of the sexes with regards to their writing" meant it was a challenge for some vital works of medieval women writers to be copied. These nuns were the scribes who made the earliest copies of her work. Grace Warrack in the twentieth century is widely recognised as the editor and translator who produced one of the first modern versions of the work.[4]

Today little remains of the original cell where Julian lived. Together with the church, it was reconstructed after the bombing raids of the Second World War.

Chapter 20

Alice Perrers, aka Alice de Windsor
(1348 – 1400)

Alice was the ruthless and highly ambitious fourteenth-century mistress of Plantagenet King Edward III of England. She was also lady in waiting to his wife, Philippa of Hainault and thought to be the inspiration behind Geoffrey Chaucer's infamous tale, *The Wife of Bath*.

Suffice to say that history and contemporary accounts do not treat her kindly. Before she came on the scene, the royal couple (married for forty years) were said to have enjoyed a happy and contented marriage.

Alice became one of the richest and probably one of the most despised women in the country. She is described as singularly ungifted in the looks department and was therefore accused of witchcraft by her detractors, for still being able to sexually and emotionally bewitch a feeble king who should have known better.

Born in the 1340s, Alice was the daughter of Sir Richard Perrers, a Hertfordshire landowner, although reports in the *St Albans Chronicle* claim her beginnings were much humbler, referring to her father as a tiler and her mother as a 'tavern whore'.

Around the 1360s, Alice joined the royal household; before 1366 she was one of the queen's ladies of the bedchamber.

Not wasting any time, she became the king's public mistress after Philippa died from the Black Death in 1369. Alice spent time with

the king's two sons, Edward the Black Prince and John of Gaunt, and allegedly used her influence to convince the king to hand over some of the late queen's jewellery. Her own jewellery collection would amount to £20,000, around £6 million today. By 1371 she was granted the manor of Wendover.

On 9 May 1374, at a tournament held at Smithfield in her honour, she dressed as Lady of the Sun and rode in her own chariot, sumptuously and extravagantly dressed, accompanied by ladies of the court who led knights on silver chains. Edward's own sons and their wives were expected to accompany the 'in your face' public display of their father's mistress.

Alice bore the king three children: one son, Sir John Southeray, and two daughters, Joan and Jane. Once Philippa was gone, Alice became head honcho at the royal court, with Edward increasingly relying on her. Their relationship became openly public, with Alice receiving land and jewellery that had previously belonged to Philippa. Alice played her hand to her advantage, using her influence with the king to elevate her own friends through the court ranks.

Alice's power was almost as immense as the dislike she inspired in others. Being the king's mistress brought her huge financial rewards and bounty – land, jewels, and lots of wine. As she rose in prominence and the ailing king relied more heavily upon her counsel, she became the scapegoat for all the ills in the latter part of Edward's reign, particularly financial affairs, because he spent so much money on her, and she had no problem enriching herself from the Crown's coffers. She ended up with an estimated fifty-six properties across the country.

In 1376, Alice became one of the figures close to the king 'impeached' in what was known as The Good Parliament. In the St Albans Chronicle, Thomas Walsingham recorded that:

They accused her of numerous misdeeds, performed by her and her friends in the realm. She far overstepped the bounds of feminine conduct: forgetful of her sex and her weakness, now besieging the king's justices, now stationing herself among the doctors in the ecclesiastical courts, she did not fear to plead in defence of her cause and even to make illegal demands. As a result of the scandal and great shame which this brought on King Edward, not only in this kingdom but also in foreign lands, the knights sought her banishment from his side.[1]

In an historic move which set the stage for the future, the court would end up deciding that women be banned from playing any part in judicial decisions.

In the early 1370s, as Edward grew older, Alice looked to the main chance – her future, and secretly arranged a marriage to William Windsor, Lord Lieutenant of Ireland, while still continuing as the king's mistress. When the arrangement was made public during the course of the Good Parliament, the king was seen as an adulterer and the public were appalled. William was held legally accountable, and Alice banned from the king's sight. Banished from court in 1376, she was allowed back by her friend and ally John of Gaunt, the Duke of Lancaster and Edward's son.

History has not treated Alice Perrers kindly; there seems to be nothing lovable or even likeable about her. But it should be noted that all the accounts of her were written by men. Rumour has it that on the king's deathbed, she removed the jewelled rings from his hands. (There are no images of her and indeed, all we have to go by is a rather biased depiction of her doing just that). Edward died, probably from a stroke, on 21 June 1377.

Alice spent a lot of time defending herself in court, especially after her husband William's death in 1384. Her final years were spent

fighting for her access to his fortune – he had left his entire estate to his three sisters. Clearly, he knew what he had married.

When Alice died in 1400, (her exact date of death is unknown although her will was made in the summer of that year and proved in early 1401, suggesting that perhaps she died over the winter period) she was buried in the parish church of St Laurence, Upminster; her grave has been lost to history.

Chapter 21

Katherine Swynford, Duchess of Lancaster (c.1350 – 10 May 1403)

Katherine is usually known for her twenty-five-year role as the mistress, and later the third wife, of John of Gaunt, (aka John Plantagenet, 1st Duke of Lancaster, 1st Duke of Aquitaine, 6 March 1340 – 3 February 1399). Born in Ghent in 1340, to put his life into historical context, he was the third son of Edward III, the brother of the Black Prince, the uncle of Richard II, the father of Henry IV and the grandfather of Henry V.

John of Gaunt was the richest nobleman in England; estimates suggest he was worth around £100 billion and owned a huge amount of land and property – more than thirty castles and estates. But rather than being overshadowed by her husband's legacy we should remember Katherine as the ancestor of the Tudor dynasty: all monarchs since Henry VII have been descended from her.

Her son Henry Beaufort became Henry IV of England and Katherine lived during some of the most important periods in history: The Black Death, the Hundred Years' War and the Peasants' Revolt. Also known as Katherine de Roet, her mother's name is lost to history, but we know her father was the Flemish knight Sir Payne or Paaon de Roet from Hainault (modern day Belgium), the chief herald of Edward III, who accompanied Philippa of Hainault as part of her retinue to England. Katherine's older sister, Philippa de Roet (1348–1387), married Geoffrey Chaucer. She had another sister, Isabel and a brother Walter de Roet.

Payne de Roet may have been married twice, as he is recorded as having four children; it's also thought that his second wife had close ties to the Hainault Royal Family. The family had a close relationship with Queen Philippa of England, who was also from Hainault. De Roet served his queen faithfully for two decades before returning to England around 1351, a year after it's thought Katherine was born; at this time de Roet was working for the queen's sister Countess Margaret.

Known for her beauty, Katherine was educated at a convent in Romsey before joining the court of King Edward III, where her sister Philippa was already a lady-in-waiting to the queen. Her eldest sister Isabel had entered a convent when Katherine was born, and Katherine would have had limited memories of either of her parents. Paon then left for Hainault, and it's thought that he did so because his second wife was already dead. At this point he leaves our story; very little is known of him and it's probable that he died a few years later.

Raised in the queen's household, where she would have been brought up alongside the royal children, including John of Gaunt and those of nobles who had also been deposited at court, Katherine would have learned the courtly skills of sewing, singing, reading, writing, French and dancing.[1]

Katherine joined the household of John's first wife, Blanche of Lancaster, after the two were married in 1359. Katherine and Blanche (born between 1345 and 1347) may have grown up in the royal household together. Blanche was the daughter of the powerful Henry de Grosmont, Duke of Lancaster; when he died in 1361, John and Blanche became the new Duke and Duchess of Lancaster, and Katherine probably had a hand in caring for their children.

When she was around twelve years old, probably before 1362, Katherine married the decade older Sir Hugh Swynford, a soldier who had fought in the Hundred Years War, who lived and held estates

in Coleby and Kettlethorpe, Lincolnshire, giving him three children, Blanche, named for her mistress (1363–?), Margaret (1364–?) and Thomas (1367/8–1432). John was godfather to at least one of her daughters, probably Blanche.

While Hugh wasn't particularly wealthy and the estates he'd inherited in 1361 weren't very fertile, with its accompanying mill in ruins, he was still a knight. For Katherine, who had some lands in Hainault but not much of a dowry herself, it was seen as an expedient and suitable match. This was a purely business arrangement and it meant Katherine and Hugh were secure in their positions as vassals of the Lancaster family; it's likely the queen herself encouraged the match. Katherine would have then split her time between working for Blanche's household and living in her own estates in Lincolnshire.

Blanche died in childbirth in 1368 and Katherine was granted an annuity for serving her, allegedly being the one who read her the last rites on her deathbed. Katherine would have returned to her home in Kettlethorpe; the following year Queen Philippa died at Windsor Castle.

Hugh was killed in November 1371 while fighting in Aquitaine; Katherine was twenty-one years old and financially vulnerable with three young children to support. Their son Thomas was too young to inherit the estates so Katherine became their ward. Additionally, Gaunt gifted her the manors of Wellingore and Waddington, both also in Lincolnshire. It meant she could afford to rent The Chancery in Lincoln, a house on the exclusive cathedral close in the 'shadow of Lincoln's cathedral'.[2]

She was recalled to court and during the late 1360s or early 1370s, became governess to Philippa and Elizabeth, the daughters of Gaunt and Blanche around the same time as she became Gaunt's mistress. While we don't know the exact date that they become lovers, historians

refer to the records of 1372 which log an increasing number of gifts to Katherine from John.

Many contemporaries dismissed her as a beguiling mistress who distracted John of Gaunt from his serious responsibilities; Benedictine monk of St Albans, Thomas Walsingham, had a huge axe to grind against Gaunt for his profligacy, leadership and politics. His relationship with Katherine gave him further ammunition to admonish him for his moral failings, for deserting his military responsibilities to ride around his estates with 'his abominable strumpet Katherine, once called Swynford'.[3]

Three years after the death of Blanche in September 1371, Gaunt married Constance of Castile in Spain and brought her back to England. Although this was not a love match, she became pregnant in 1372. They had one child together, a daughter Catherine, born in 1373, while Katherine continued to grow her own family with John, meaning that their affair was ongoing while Constance was pregnant. That Constance knew what was going on between Katherine and her husband is likely; indeed, John sent away her ladies in waiting to a convent for a year for gossiping about the affair.

When Edward III died on 21 June 1377 (his mistress had been Alice Perrers and John had supported her dismissal from court), John then supported his young nephew, King Richard II, son of John's eldest brother Edward the Black Prince, who had died on 8 June 1376, all the while rumoured to want the throne for himself. With the people rising up against the hugely unpopular Poll Tax, which John introduced in 1371, it was his virtual head on the block at the time of the Peasant's Revolt of 1381.

In burning resentment at his lifestyle, his lavish London residence Savoy Palace was destroyed by fire, with John narrowly surviving the flames. In order to assuage the furious mob and restore public affection for him, he took the most politically astute decision for

himself – publicly renouncing his relationship with Katherine, and returning to his wife Constance.

Katherine retired to Lincoln and the two didn't see each other for over a decade, although their correspondence and exchanging of gifts continued. In March 1387, King Richard II and his wife Anne of Bohemia came to visit her and in April of that year made her a Lady of the Garter, the ceremony taking place at Windsor.

After Constance died in March 1394 at Leicester Castle, and after having secured a Papal disposition and the permission of King Richard, in a move that was scandalous, causing 'great shock' and 'astonishment' among the nobles of England and France, John finally married his mistress on 13 January 1396 in Lincoln Cathedral; this made her Lady Katherine Swynford, Duchess of Lancaster and First Lady of England.[4]

It was only then that their four children, collectively known as the Beaufort Bastards (John Beaufort, 1st Earl of Somerset, Henry Cardinal Beaufort, Thomas Beaufort, 1st Duke of Exeter and Joan Beaufort, Countess of Westmorland), were legitimised by the Pope and Richard II.

John took part in the crusades and served Richard II at court. Henry, the second son, was chosen for the church and was educated at Cambridge and Oxford. Joan married Sir Roger Ferrers in 1391 at the age of fourteen, while the youngest, Thomas, continued to live in his father's household with her.

There was a four-year gap between Joan and Thomas, which suggests there may have been children born during that time who didn't survive due to the high infant mortality rate or miscarriage – and that their brief lives weren't recorded because the children were considered bastards.

Katherine became First Lady of England without ever being crowned queen. Just three years later, on 3 February 1399, John of

Gaunt died at the age of fifty-eight and was buried alongside his first wife, Blanche. Once again, Katherine retired to Lincoln.

Katherine died in her early fifties on 10 May 1403 and her tomb is in Lincoln Cathedral; she is buried alongside her daughter Joan. Every year, on the date of her death, her name is recited in the Evensong prayers.

As for her children with John of Gaunt, Henry became Cardinal Beaufort; daughter Joan married into the Neville family and was grandmother to Edward IV and Richard III; Thomas married Margaret Neville; and their eldest son, John Beaufort, was great-grandfather of Henry VII, and father-in-law to James I of Scotland through the marriage of his daughter, another Joan, to the Scottish king. Katherine's great granddaughter was Margaret Beaufort, Countess of Richmond, and mother to the future Henry VII, the first Tudor king.

Chapter 22

Christine de Pizan (1364 – c. 1430)

Apoet and author at the court of King Charles VI of France, she was born Cristina da Pizzano in Venice, Italy. Around 1368, her family moved to Paris where her father, Tommaso di Benvenuto da Pizzano, was a respected intellectual, an astrologer and a physician at the court of King Charles V of France.

Her father's proximity to the king and the royal favour, affection and patronage bestowed upon Tommaso meant that Christine had a luxurious upbringing at court. Her parents were enlightened enough to ensure she was given an education equal to her younger brothers; she learned Greek, Latin, literature, philosophy, and medicine, spending considerable time reading in the beautiful library of the royal palace of the Louvre. Christine thus commands attention not least because she was that rarity of a woman at the time: educated.

At the age of fifteen, she was married to E'tienne du Castel, a notary and secretary to the king. The marriage was a happy one, producing two sons and a daughter. Unfortunately, Charles V, then a few years later her father Tommaso, died, followed soon after by her husband around 1390, in an epidemic of the bubonic plague.

The immediate effect of the king's unexpected death at the age of forty-four for Christine's father had meant that he was out of a job. Additionally, the promises of monetary gifts from books that Charles had made, were never documented on paper. His patronage and financial support were soon cut off. So, Thomas's salary took a

large hit and he'd not put much aside, deciding instead to give much of what he did earn to the poor.

Her brothers returned to Italy, and Christine was left in Paris as a widow, with three children as well as her mother and niece to support. She was now head of the family. Her options seemed limited. The traditional and expected course of action would have been to remarry for financial security and to ensure a roof over her head. Christine, however had other ideas; she had also promised her husband that she wouldn't marry anyone else. She spent several years tied up in legal wrangles, attempting to secure a financial settlement from her father's former fortune.

In 1394, around four years after the death of her husband, Christine began writing poetry. It became popular quickly, reaching beyond France to the Italian and English courts. She admits herself that part of the appeal of her work was that it was written by a woman; 'because poetry written by a woman was such a novelty'.[1]

She was the first woman in Europe to make a successful living through writing; in her diary, she noted that she 'had to become a man'. She wrote in French and was famous for her poetry, most notably used to convey her grief at the loss of E'tienne. To support her family, she also became manager of a scriptorium, overseeing the work of calligraphers, miniaturists and bookbinders. She caught the attention of potential patrons by sending them poems. Her works include:

One Hundred Ballads (1393 CE)
Moral Lessons (1395 CE)
Letter of the God of Love (1399 CE)
Letter of Othea to Hector (1399 CE)
The Tale of the Rose (1402 CE)
On the Mutability of Fortune (1403 CE)

The Book of the City of Ladies (1405 CE)
The Treasure of the City of Ladies (1405 CE)
The Book of Feats of Arms and Chivalry (1410 CE)
The Book of Peace (1413 CE)
The Tale of Joan of Arc (1429 CE)

Her patrons included Queen Isabella of Bavaria, (the wife of Charles VI of France, and for whom she wrote *The Book of the Queen*, thought to have been written between 1410 and 1414 in Paris), Louis I, Duc d'Orleans, and the British 4th Earl of Salisbury. It was the Earl who offered to take Christine's son Jean into his household as a companion for his son. The Duke of Burgundy commissioned her in 1404 to write a biography of his recently deceased brother King Charles V.

As well as being a writer, she was a historiographer who fought for women's equality. An early feminist, she wrote two books in defence of women: *The Book of the City of Ladies* and *The Treasure of the City of Ladies*.

The Book of the City of Ladies (*Le Livre de la cite´ des dames*) in 1405, imagines a city populated by notable women from history including Dido, the poet Sappho, Eve, Esther, Queen Isabella of Bavaria, the Virgin Mary and Zenobia. In one particular excerpt, she argued that education for girls is just as important as for boys, but it was men who were aghast at the thought of women knowing more than they did: 'If it were customary to send little girls to school like boys … they would learn as thoroughly the subtleties of all the arts and sciences.'[2]

Debating vociferously with the king's secretaries, she was extremely vocal in her criticisms of a misogynist allegorical poem called 'Roman de la Rose', first written by Guillaume de Lorris and then continued by Jean de Meun in the thirteenth century. Christine argued that it was unfairly biased against women, portraying them as existing just to satisfy men. Her arguments meant that the status of women

was ripe for discussion within the French court; indeed, she had the support of key establishment figures including the Chancellor of the University of Paris.

Christine received invitations to live in and write at foreign courts – from monarchs including Henry IV of England and the Duke of Milan. She preferred however, to remain in Paris, while the Duke of Berry collected a copy of nearly every book she wrote, and her writings continued to be translated and spread abroad.

Political turmoil in France soon led to violence between the leading Houses of Orleans and Burgundy. In 1407 one of Christine's patrons, Louis, Duke of Orleans was murdered on the orders of his own cousin John, Duke of Burgundy, also a patron. Christine found herself at the heart of a civil war, her position fast becoming precarious. By 1418 she was forced to leave the city of Paris. For her own safety, at the age of fifty-three years old, she retired to the convent of Poissy. Her writing output went quiet between 1418 and 1429 and there is little indication of how she spent those years.

She died probably at the age of sixty-five, around 1430, but not before writing in 1429 an epic poetical and historical treatise in praise of Joan of Arc, *Le Ditie´ de Jehanne d'Arc* (*The Tale of Joan of Arc*). The only known work on Joan written during her lifetime, it reflects the national wonder at Joan's achievements and military success, as well as a sense of the country's pride.

Excerpts from the English translation follow:

I, Christine, who have wept for eleven years in a walled abbey where I have lived ever since Charles (how strange this is!) the King's son– dare I say it? –fled in haste from Paris, I who have lived enclosed there on account of the treachery, now, for the first time, begin to laugh;

XIII

And you Charles, King of France, seventh of that noble
name, Who have been involved in such a great war before
things turned out at all well for you, now, thanks be to
God, see your honour exalted by the Maid Who has laid
low your enemies beneath your standard (and this is new!)

XIV

in a short time; for it was believed quite impossible
that you should ever recover your country which you
were on the point of losing. Now it is manifestly yours
for, no matter who may have done you harm, you have
recovered it! And all this has been brought about by
the intelligence of the Maid who, God be thanked, has
played her part in this matter!

XXII

Blessed be He who created you, Joan, who were born
at a propitious hour! Maiden sent from God, into whom
the Holy Spirit poured His great grace, in whom [Le.
the Holy Spirit] there was and is an abundance of noble
gifts, never did Providence refuse you any request.
Who can ever begin to repay you?

XXIII

And what more can be said of any other person or of
the great deeds of the past? Moses, upon whom God
in His bounty bestowed many a blessing and virtue,
miraculously and indefatigably led God's people out
of Egypt. In the same way, blessed Maid, you have
led us out of evil!

XXV

For if God performed such a great number of miracles through Joshua who conquered many a place and cast down many an enemy, he, Joshua, was a strong and powerful man. But, after ail, a woman – a simple shepherdess – braver than any man ever was in Rome! As far as God is concerned, this was easily accomplished.

XXVI

But as for us, we never heard tell of such an extraordinary marvel, for the prowess of ail the great men of the past cannot be compared to this woman's whose concern it is to cast out our enemies. This is God's doing: it is He who guides her and who has given her a heart greater than that of any man.

XXXV

A little girl of sixteen (isn't this something quite super natural?) who does not even notice the weight of the arms she bears – indeed her whole upbringing seems to have prepared her for this, so strong and resolute is she! And her enemies go fleeing before her, not one of them can stand up to her. She does all this in full view of everyone,

XXXVI

and drives her enemies out of France, recapturing castles and towns. Never did anyone see greater strength, even in hundreds or thousands of men! And she is the supreme captain of our brave and able men.

Neither Hector nor Achilles had such strength! This
is God's doing: it is He who leads her.

XLII

She will restore harmony in Christendom and the Church.
She will destroy the unbelievers people talk about, and
the heretics and their vile ways, for this is the substance
of a prophecy that has been made. Nor will she have
mercy on any place which treats faith in God with
disrespect.

XLIII

She will destroy the Saracens, by conquering the Holy
Land. She will lead Charles there, whom God preserve!
Before he dies he will make such a journey. He is the
one who is to conquer it. It is there that she is to
end her days and that both of them are to win glory.
It is there that the whole enterprise will be brought to
completion.

XLIV

Therefore, in preference to all the brave men of times
past, this woman must wear the crown, for her deeds
show clearly enough already that God bestows more
courage upon her than upon all those men about whom
people speak. And she has not yet accomplished her
whole mission! I believe that God bestows her here
below so that peace may be brought about through her
deeds.

It was the first poem written about Joan and the only one written while the 'Maiden' was still alive; it is hugely exciting as both a historical and poetic document.

Christine's impact on fellow women was likely beyond her expectations, with the next generation of influential women, including Mary of Hungary and Marguerite of Austria, owning and reading copies of her work.

Chapter 23

Margery Kempe (c.1373 – after 1438)

Margery was a medieval pilgrim and mystic who lived in the East Anglian town of Lynn (now King's Lyn) in the early fifteenth century.

Born Margery Burnham/Brunham sometime around 1373 into a family of wealthy merchants, she was a contemporary of both Julian of Norwich's revelations and Geoffrey Chaucer. Her father was mayor of the town five times between 1370 and 1391, a member of parliament, justice of the peace, and chamberlain. Her mother's information is unknown.

Although illiterate, she was the author of *The Book of Margery Kempe*, the earliest known autobiography in English; she dictated her words to three male scribes or amanuenses, between 1432 and 1436. The first was an Englishman, probably her son, who lived in Germany, but he died before the work was completed. After this, the work was taken up by a priest, who later became disillusioned by Kempe's reputation and passed on the work to the third and final scribe.

The work, running to over 300 pages, is a travelogue detailing her various pilgrimages, 'hyr felyngys and revelacyons and the forme of her levyng' (her feelings and revelations and the form of her living), and Margery refers to herself in the third person as 'the creature' or 'this creature'.

It was finally completed in July 1436 with excerpts published in 1501 by Wynkyn de Worde, who worked with printer William Caxton

in England and also published the works of Chaucer and Sir Thomas Malory. The only surviving and partial manuscript by a scribe called 'Salthouse', running to just seven pages had, until relatively recently, belonged to Carthusians at Mount Grace Priory in Yorkshire in the fifteenth century. It contained four sets of annotations.

Margery's full and complete book, probably a copy of the original, was rediscovered and identified in 1934 by medievalist Hope Emily Allen, after centuries in a cupboard at the home of Lieutenant Colonel William Erdeswick Ignatius Butler-Bowdon of Southgate House, Chesterfield, Derbyshire. In a fitting quirk of fate, the Butler-Bowdons themselves had been a family of recusants. Fifty years later, the British Library bought it at auction and digitized it for public reading consumption in 2014.

Since the book's discovery, historians, scholars and readers have 'variously suggested that Kempe was a significant example of late medieval religiosity, a proto feminist, a mentally ill hysteric, or a woman suffering from post-partum depression and menopausal symptoms.'[1]

An ordinary middle-class woman, she married her husband, businessman and merchant John Kempe, when she was twenty years old, and went on to have fourteen children, none of whom are mentioned in her book, beyond their conception.

She had a very difficult birth with her first child and 'went owt of hir mende'[2] (went out of her mind) for around two years; today it's likely she would have been diagnosed with post-natal depression. She describes having visions of fire-breathing demons who encouraged her to kill herself. Her terrified neighbours however, thought it was a form of Satanic possession.

Margery claimed to have been visited by visions of Jesus, dressed in purple silk, had visions of Hell and had to be physically restrained to her own bed after trying to bite and scratch herself. After her first

vision of Jesus sitting beside her ('Daughter, why have you forsaken me, and I never forsook you?'[3]) she recovered and continued her regular way of life. Many of her contemporaries however, had serious doubts about the veracity of her visions. The power of the medieval church was such that with priests holding the vocal authority they did, what they said was deemed fact, so if they truly believed her visions came from God, they would have said as much.

Margery was vain, highly conscious of her appearance, clothes and fashion. When her fresh attempts at work and business (opening a brewery and then a mill) were shunned by the community 'out of pure covetousness', she believed her failures were a punishment from God. Performing an abrupt volte face, she turned to a life of religious contemplation.

Convinced that sex made her unclean, and with the agreement of her husband, she pledged a vow of chastity and became a 'vowess'. The deal with John was made with certain conditions; that before she left on her journey to Jerusalem, she would clear all his debts. This she agreed to, although she refused his other suggestion of breaking her Fast on Friday to share an evening meal with him.

Margery attended church and went to confession several times a day. Her book recalls that one night she heard such heavenly sweet music, it made her weep. From then on, whenever she heard music, or experienced any reminder of Christ and his Passion (sufferings), she would dissolve into tears and histrionic fits, dramatic performances for which she became renowned. She experienced doubts that her visions were sent by demons of Satan rather than Christ; to assuage her concerns she sought advice from other religious figures of the time including Julian of Norwich in 1413, who provided 'Holy conversation', advising her that she herself was 'enclosed within a house of stone', but Margery, 'my sister, wander free.'[4]

In 1414, she went on a series of pilgrimages as part of her personal Holy quest; her husband accompanied her on several of her visits across England, including Canterbury, York, London and Norwich; she travelled without him to Jerusalem in 1415, Mount Zion and Bethlehem, as well as later to Germany, Rome, Assisi, Bologna, Venice and Santiago. She begged her way home, giving all she had to the poor. Upon her return, she was questioned by church authorities on the grounds of heresy at Leicester, and stood trial at York, Hull, Hessle and Beverley.

Claiming that Jesus bade her only wear white as a symbol of her purity and rebirth of spirit, one would imagine that those who had known Margery before her religious revelation would have felt not a little cynical at her wearing a colour usually reserved for nuns, especially as, having had several children, she was most certainly not a virgin, and embarking on a vow of pious devotion. It didn't make her popular.

Indeed, fellow pilgrims grew tired of her lecturing them for talking about what she saw as frivolous topics while on their Holy endeavour. She became something of a social pariah, relegated to the end of the table at mealtimes.

In 1418 she returned to Lynn, before beginning the scribing of her book in 1432, the same year her husband and son died. The next year she sailed to Gdansk (Poland) via Norway and her last record is in 1439. Her exact date of death is unknown but it is believed she also outlived Joan of Arc.

A statue of Margery, claimed to be the only one of its kind in the world, was revealed in the Portuguese province of Gois at the end of 2020. It was designed to celebrate her pilgrimage and inaugurated at the entrance of a medieval bridge that she once crossed. The route, the English Way, is said to be traversed by 15,000 pilgrims annually, en route to Santiago de Compostela, with visits occurring since at least the eleventh century.

Chapter 24

Joan of Arc (1412–1431)

One life is all we have and we live it as we believe in living it. But to sacrifice what you are and to live without belief, that is a fate more terrible than dying.[1]

N o self-respecting list of heroic women would be complete without Joan, aka the martyred Maid of Orleans.

Born around 1412 and burned at the stake in 1431, Joan's real name could have been Jehanne d'Arc, Jehanne Tarc, Jehanne Romée or possibly Jehanne de Vouthon.

She grew up an illiterate peasant in north-eastern France, in a village called Domremy; her father was a farmer and her mother, Isabelle Romée, was an extremely observant Catholic who passed on her love for her faith to her daughter.

Joan took a vow of chastity and refused to accept a marriage arranged for her by her father. Legend has it that she heard voices and had visions – (symptoms perhaps of what modern medicine would classify as anything from schizophrenia and bipolar disorder to bovine tuberculosis) urging her to cut her hair into the famous 'bob' and drive the English from France.

She had no military experience but was persuasive enough to convince Prince Charles of Valois to let her lead an army to Orleans, the French town besieged by the English. Legend has it that Charles agreed to take Joan's advice after a private meeting between the two, where Joan revealed information to the future king that could only

have come from God. Whatever was said, he emerged as seemingly convinced as she was that she would crown him king at Reims. They won a decisive victory resulting in Charles being crowned King Charles VII in 1429.

Joan wanted to continue and retake Paris, but with her position of favour on the wane, the king was persuaded otherwise.

Interestingly, for a woman remembered as a fighter, Joan, dressed in white armour and riding on a white horse, never actually fought, although she was wounded twice. She was more of a strategist and token mascot to inspire bravery and heroism in the French armies of Charles VII in the battles between the French and English during the One Hundred Years War.

At the king's command, in 1430 she set off to fight the forces of Burgundy at Compiegne. She was captured outside the city gates by the English and taken to the castle of Bouvreuil. Charles did nothing to save her. He dumped her like a tonne of bricks and left her to rot as a prisoner, chained to her bed for a year, to face the inquisitors, who could neither break her spirit nor find her guilty of heresy or witchcraft.

She might have been a teenager, but she didn't hesitate to school her elders for swearing or missing Mass. During her trial at Rouen, (she had seventy charges against her, including witchcraft) when asked by a churchman what languages the 'voices' in her head spoke, she furiously retorted that they no doubt spoke better French than he did.

She eventually caved in, denied she'd had divine intervention and signed her confession. But stubborn and contrary to the end, she reneged a few days later and dressed herself once more in men's garb, resulting in her conviction as a relapsed heretic. In the end, her fate would be decided based on her cross-dressing – something her captors argued went against the Bible. The English burned her at the stake in Rouen on 30 May 1431. She would be burned at the

stake a total of three times in order for her organs and body to be completely destroyed. Her ashes were allegedly found in 1867 in the attic of a Parisian apothecary, but tests proved them to be fake (and the remains of an Egyptian mummy and a cat); they remain in a museum dedicated to Joan in Chinon.

It would take twenty years for Charles to order a retrial to restore Joan's reputation. She was canonised as a saint in 1920 and her legend immortalised in art, literature, and film.

Chapter 25

Isabella of Castile
(22 April 1451 – 26 November 1504)

Awarrior queen, also known as Isabella the Catholic and Queen of Castile ('land of castles') and Leon. She cleared her kingdoms of debt, introduced reforms, unified Spain, drove 'heretics' and the Moors out of Spain, and massively reduced the crime rate.

Her father was John of Castile, and her mother was Isabella of Portugal; when her father died in 1454, Isabella's half-brother Henry became the new king, Henry IV of Castile. (He was nicknamed 'The Impotent' because he suffered a form of gigantism and reportedly had a bulb shaped penis).

Isabella is said to have hated her half-brother, who had forced her away from her mother and into court, so he could keep an eye on her. He in turn wanted to establish his own daughter, Joanna, as his heir, but his nobles pressurised him into choosing Isabella's younger brother Alfonso instead. He, however, died under suspicious circumstances in 1468 – of either poisoning or the plague. The nobles then pushed for Isabella to take the crown; being diplomatic and playing a longer political game, she refused to cross her half-brother. He rewarded her loyalty by naming her as his successor.

Henry was furious when Isabella married her second cousin Ferdinand (the son of John II of Aragon and Juana Enríquez) without his royal consent; he dropped her as his heir, with Joanna once again

being moved into prime position. The kingdoms of Castile and Aragon were formally united when Ferdinand was crowned king of Aragon in 1479.

When Henry died in 1474, it led to a civil war and power struggle between Joanna and Isabella. Isabella triumphed and was crowned queen. Joanna opted to move to a convent.

Ferdinand and Isabella established the dreaded Spanish Inquisition in 1480. It was aimed at those Jews and Muslims who had outwardly converted to Christianity under duress, but who were suspected of secretly practicing their faith in private.

In 1492, they issued the Alhambra Decree, also known as the Edict of Expulsion. The Jewish population of the kingdom, who had lived on the Iberian Peninsula for over 1,700 years, were given an ultimatum: convert, leave or die. Those who converted to become 'New Christians', were called 'marranos' or 'pigs'.

Isabella firmly believed that despite their conversions, they remained Jews in secret. She established a Royal Inquisition to chase those who were deemed 'judaizers', and with the dedicated zeal of her Grand Inquisitor, Tomas de Torquemada, vowed to rid Spain of a community that pre-dated Christianity. There is much debate over the exact number of Jews who left, with figures as varied as 40,000 to 100,000. Their efforts and success in what they considered 'purifying' their kingdom of heretics were rewarded by Pope Alexander VI, who gave them the title 'Catholic Monarchs'.

In 2015, with the Jewish population in Spain now one of the smallest in Europe (at less than 50,000 in a population of over 46 million), the Spanish Parliament enacted a law of return to its Sephardic Jews (those who can trace their routes to Spain). Sepharad is the Hebrew word for the Iberian Peninsula. The law declared that after 'centuries of estrangement', Spain would now welcome back

'Sephardic communities to reencounter their origins, opening forever the doors of their homeland of old.'[1]

As to Isabella and Ferdinand's children; the infanta Isabella was born in 1470; she would die in childbirth, with the grandson later dying too; the heir apparent, 'my angel', Juan was born in 1478 but died at the age of nineteen, leaving Queen Isabella devastated by his death; and the infantas Juana (called Juana la Loca – Joan the Mad), Catalina (later being known as Catherine of Aragon – the first wife of Henry VIII of England), and María followed.

Isabella was crowned on 13 December 1474. The geographical and political reality of their marriage meant that initially they were apart for long periods of time. Isabella was constantly on the move around the country, in one instance actually losing an unborn child because of the pace at which she travelled to fulfil her obligations. Isabella travelled with her armies on every military campaign and was instrumental in planning strategy. Ferdinand had numerous affairs and he had at least two illegitimate daughters, causing Isabella intense hurt and jealousy.

Having united Spain through her marriage to Ferdinand, together they supported and financed the expedition of Christopher Columbus (when he brought Native American slaves before her as a gift, Isabella was horrified and demanded they be freed). Columbus had tried for years to get funding for his expedition, initially in 1484 from King John II Portugal, then in 1487 from King Henry VII of England and King Charles VIII of France. His efforts were to no avail until eventually, Ferdinand and Isabella agreed to sponsor his trip to discover a westward route to China, India, and Japan.

They were more than happy for him to risk life and limb to expand their trading opportunities, and their religion, into the Indies. On his part, the deal he made with the Spanish royals, called The

Capitulations of Santa Fe, meant he could name himself admiral, viceroy, and governor of any piece of land he discovered.

He was also entitled to a huge 10 per cent of any 'merchandise, whether pearls, precious stones, gold, silver, spices and other objects'[2] that he came across on those new lands., He set sail from the Spanish port of Palos in August 1492 with the *Nina*, *Pinta* and *Santa Maria*.

Columbus didn't 'discover' North America; he was the first European to discover the Bahamaian group of islands (12 October 1492) and the island later called Hispaniola – now modern-day Haiti and the Dominican Republic (the *Santa Maria* ran aground off the coast and was abandoned). Columbus thought that these were the Indies. Columbus believed he had a divine purpose but in 1499, word of his appalling and brutal treatment of indigenous peoples reached the ears of Ferdinand and Isabella; he was arrested in disgrace, sent back to Spain in chains and a new governor was put in his place.

Collectively Ferdinand and Isabella were known as the Catholic monarchs; in 1482 they led a military campaign on Granada, the last stronghold of the Muslim conquest of Spain. On 2 January 1492, Boabdil, the last Muslim king in Spain, was forced to leave the Alhambra. He led his family through the 'Pass of the Moor's Sigh'. Isabella's triumph was echoed and championed across the Christian world: Henry VII of England ordered a hymn of praise at St Paul's Cathedral; Spanish cardinal Rodrigo Borgia (father to Cesare and Lucrezia, and who would become Pope Alexander VI eight months later) organised celebratory bullfights in Rome.

Together, they had triumphantly completed the Reconquista – a movement to end Muslim rule in Iberia. When Isabella died at the age of fifty-two in 1504, Ferdinand mourned her deeply, calling her 'the best and most excellent wife a king ever had'.[3]

She was entombed in the Royal Chapel of Granada, while her daughter Joanna became queen. Ferdinand served as regent until his own death twelve years later.

Hernando del Pulgar, a fifteenth-century Jew and Castilian historian who converted to Catholicism, said of Isabella: 'She was very inclined to justice, so much so that she was reputed to follow more the path of rigour than that of mercy, and did so to remedy the great corruption of crimes that she found in the kingdom when she succeeded to the throne.'[4]

Their daughter Catherine would go on to first marry Arthur, the Prince of Wales, and then be the first wife of his brother Henry, later King Henry VIII; she would become Queen of England. This makes Isabella of Castile the grandmother of Queen Mary I of England.

Chapter 26

Anne Neville (11 June 1456 – 16 March 1485)

Anne Neville was an English queen, the younger of the two daughters and co-heiresses of Richard Neville, 16th Earl of Warwick and Anne Beauchamp. Her father was known as the 'Kingmaker', due to his influence in shaping who would succeed the English throne; instrumental in defeating Henry VI and placing the crown on Edward IV, he went on to change his mind; by 1469 he had decided he wanted the Lancastrian Henry VI back on the throne.

Anne was born at Warwick Castle in Warwickshire, and into an historic era – the start of the War of the Roses, (so-named because the feuding houses had white and red roses as their badges) with the Houses of Lancaster and York vying for control of the English throne.

Anne's mother was heiress to a considerable fortune; upon her death, that passed onto her own two daughters, making both Anne and her older sister Isabel highly desirable in the matrimony market. Their father pledged his daughters in marriage to the brothers of King Edward IV, Isabel to George, Duke of Clarence and Anne to his brother, Richard the Duke of Gloucester. Those engagements, however, were nullified when their own father switched allegiances against Edward IV. The family were forced to flee to France, where Isabel and George married in secret; George also switched sides to try and take the throne for himself, with a promise of support from Isabel's father. It was all very complicated, with two sisters married to two brothers on opposite sides of the political spectrum.

When Richard Neville attempted to switch back his support to Henry VI and Margaret of Anjou (who despised him), as a token of his renewed loyalty, he pledged Anne in marriage to their only son, Edward of Westminster. She duly became Princess of Wales at the Chateau d'Amboise in France, followed by their marriage around 13 December 1470.

Richard Neville's decision to support the Lancastrians turned out to be an historic mistake; on 14 April 1471, the Yorkists won the Battle of Barnet and he and one of Anne's uncles were killed. Shortly afterwards, her new husband Edward would be killed at the aged of seventeen, at the Battle of Tewkesbury on 4 May 1471.

Together with her mother-in-law, Anne was taken prisoner in Coventry by her own brother-in-law, the Duke of Clarence (who was married to Anne's sister Isabel). He wanted all the Neville money and fortune under one roof and refused to let her go. Anne's mother had fled to Beaulieu Abbey for sanctuary; as the widow of a traitor, her life was in peril and if captured, she would be charged with treason. While here, the Duke of Clarence controlled her money and lands.

Anne's life was in danger, and she was very much a political pawn in a man's world. It was Clarence's brother, Richard, Duke of Gloucester, who (depending on the point of view), either kidnapped or rescued her. Clarence was furious. While Anne went on to marry Richard on 12 July 1472 at Westminster Abbey (just over a year-and-a-half after her first marriage to Edward), he had to forfeit much of her lands and inheritance to do so.

Anne and Richard had originally met as children, when Richard was sent to Middleham Castle in Wensleydale (which came into the Neville family's possession in 1270) to be mentored by Anne's father, the Earl of Warwick, who was also his older cousin. Anne and Richard were first cousins, once removed and as such, they needed permission from the Pope to marry – although it's not certain whether that

permission was ever given. And so it was that two brothers married two sisters and Anne became Duchess of Gloucester, and later queen of England.

Anne's sister Isabel died in December of 1476 at the age of twenty-five, either from tuberculosis or from complications relating to the birth of her fourth child, who had died in infancy two months earlier. Isabel's husband, the Duke of Clarence, accused one of her ladies-in-waiting of poisoning her. Clarence fell afoul of his brother, Edward IV, who had him imprisoned and charged with treason for attempting to delegitimise his throne. He was executed at the Tower of London on 18 February 1478; rumour has it that he drowned in a butt of malmsey wine. Anne was left in sole charge of her two nephews, Edward, and Richard, both of whom had a more direct claim to the throne than her own husband.

On 9 April 1483, Edward IV died. Richard, Duke of Gloucester, was named Lord Protector for his twelve-year-old nephew Edward V. On 25 June 1483, Richard claimed his brother's marriage invalid, and had his nephews proclaimed illegitimate.

Richard is suspected of murdering twelve-year-old Edward V and nine-year-old Richard, Duke of York. He had them placed in custody in royal apartments at the Tower of London, allegedly to prepare the eldest, Edward, for his coronation. Instead, Richard took the throne as Richard III, proclaiming himself king. After 1483, there were no more sightings of the young boys, known to history as the tragic 'Princes in the Tower'.

Anne was crowned on 6 July 1483 and their son Edward (born at Middleham in around 1473) was made Prince of Wales. He in turn died suddenly on 9 April 1484 at the age of ten, at Sheriff Hutton, while his parents were away.

There is no known true likeness of her; she died on 16 March 1485 at Westminster, probably from cancer or tuberculosis (or, as rumour

has it, possibly poisoned by her husband) at the age of just twenty-eight.

She was buried in an unmarked grave at Westminster Abbey without any memorial. She also didn't share a tomb with her husband, whose skeleton was famously discovered under a car park in Leicester, where his body was buried after his defeat to Henry Tudor at the Battle of Bosworth, and subsequently reburied at Leicester Cathedral in 2015.

In 1960, the Society of Richard III erected a bronze plaque in Anne Neville's memory at Westminster Abbey in as close as proximity to where she might be as possible.

The inscription on the plaque reads:

Anne Neville 1456–1485 Queen of England, younger daughter of Richard, Earl of Warwick called the Kingmaker, wife to the last Plantagenet King Richard III. Requiescat in Pace.

Chapter 27

Lucrezia Borgia
(18 April 1480 – 24 June 1519)

The background: Italy isn't unified but is instead a collection of warring papal states, duchies, kingdoms and republics.

The scene: Renaissance Italy. Corruption. Incest. Extravagance. Excess. Poison. Sex. Seduction. Privilege. Ruthless political intrigue. Illegitimate children. Depravity. Blackmail. Bribery. Nepotism. (And that was just on a quiet day.)

This is the tale of a fifteenth-century Italian woman born into the real-deal of a crime family, a woman whose name continues to spark controversy and interest long after her death. Was she an innocent pawn, used ruthlessly by her social climbing, politically ambitious family? A family whose escapades would make life at the 'Sopranos' house look like afternoon tea at a convent? Or was she a willing participant in their scurrilous schemes and plotting, a cold-hearted poisoner of rivals, a heartless harlot? The truth may be somewhere in between.

The beautiful Lucrezia was the illegitimate daughter of Pope Alexander VI, Rodrigo Borgia and his long-term mistress Vannozza dei Cattanei, who also provided siblings in the form of Cesare Borgia, Giovanni Borgia and Gioffre Borgia. Alexander acknowledged five children as his, but there could very well have been more. Lucrezia wasn't brought up by her mother, instead living in the household of Adriana Orsini, a cousin of her father. The Borgias originally came

from Spain – and the Italians saw them as outsiders. Alliances would be essential, as would an impeccable education. She learned Latin, Greek, Italian and French and enjoyed poetry, dancing and music.

Engaged twice before the age of twelve, Lucrezia's first political marriage of alliance was to Giovanni Sforza, Lord of Pesaro and the nephew of the Duke of Milan, in 1493. Fifteen years older than Lucrezia, poor twenty-six-year-old Giovanni was urged to bed his wife in front of the Borgias and his own family to prove his manhood. Despite this public act, in 1497, when the relationship was no longer politically expedient for the Borgia family, the marriage was annulled based on non-consummation.

Alexander claimed that Giovanni, despite it being known that his first wife had died in childbirth, was tragically impotent. Giovanni, furious, retaliated by accusing Lucrezia of incest with both Alexander and Cesare. The insinuation haunted the Borgia family for centuries. Even messier, popular gossip recalls that in February of that year, during a stay in Rome, Giovanni ran away, in disguise, to Pesaro, having been warned by Lucrezia that her father and brother were going to kill him.

However, someone consummated something because Lucrezia, sent to a convent during the annulment, had an illegitimate son called Giovanni, hidden from public view until he was three years old.

Italian society went into overdrive, taking wild guesses at the paternity of the child. Rumours of incest raged, not helped by the Papal Bulls issued on the matter. The first stated that Giovanni's father was Cesare, Lucrezia's brother; the second Bull then awarded paternity to her own father, Rodrigo. The likely actual father, Pedro Perotto Calderon, a servant in Pope Alexander's household, was conveniently found drowned in the River Tiber in February 1498.

Lucrezia's second marriage later that year, also for her family's political gain, was to Alfonso V of Aragon, Duke of Bisceglie and

the illegitimate son of the king of Naples. This liaison didn't end so well either; despite apparently being a happy union, with a son named Rodrigo for his grandfather born in 1499, the prince was strangled by Cesare. Once again, a husband had outlived his usefulness. Lucrezia, at the age of twenty years old, was a widow.

There were also the feverish whispers of Lucrezia's adroitness at poisoning enemies; she allegedly had her own bespoke ring to store the stuff and during the Renaissance, poison was described as 'a woman's weapon of choice'.[1]

Arsenic was the poison of choice; whether Lucrezia Borgia used it or not, the weapon was a great equalizer. Murder required administering a poison in repeated or large doses, tasks that women could conveniently perform since they were trusted with the preparation of food and the administration of medicines. As a group, women had plenty of reasons to commit murder, too – lack of economic opportunity, limited property rights, and difficulty in escaping the marriage bond. In his recent book *Elements of Murder: A History of Poison*, John Emsley describes multiple cases of women who killed to gain courtly power, get rid of husbands, collect insurance, cover up swindling and theft during domestic employment, and receive inheritances. In France, arsenic came to be called *poudre de succession*, 'inheritance powder.'[2]

Then there was her scandalous involvement in events of legendary sexual excess, such as the Banquet of the Chestnuts on 30 October 1501, the night before Hallowe'en, an orgy at the Palace of Rome for nobles and senior members of the Catholic Church, complete with courtesans and prostitutes, all organised (naturally) by the Borgia family. It was an event that the Pope himself took part in.

The courtesans were the best the city of Rome had to offer, the exclusive 'Cortigiana', which means 'lady-in-waiting'. Most of the accounts of this event, still gossiped about to this day, are based on

a diary entry by the banquet's master of ceremonies Liber Notarum Johann Burchard, who, it should be noted, was not a fan of the Borgia clan.

It's important to take that into consideration, when measuring up whether the Banquet was as scandalous as portrayed, as to whether it was painted that way to be a hatchet job on the Borgias by their many enemies from prominent Italian families.

Burchard writes that fifty honest courtesans were at the party; they acted as dancers, entertainers, conversationalists, and servers. Their clothes didn't stay on for very long. Indeed, once they were off, specific games with chestnuts began. Members of the clergy would deliberately throw chestnuts on the floor for the naked courtesans to crawl on their hands and knees to retrieve in their mouths. That's when the orgiastic excesses began – and whomever lasted the longest in sexual intercourse was declared the winner.

True or not, written in bias or not, this 'single party became the most notorious banquet of all medieval history.'[3]

Onwards with marriage number three for Lucrezia, which occurred in 1502, this time to Alfonse d'Este, Prince of Ferrara. This was a case of third-time lucky; although they both had love affairs, including Lucrezia's with her own brother-in-law, it was a happy union producing eight children, only four of whom survived infancy. Such was Lucrezia's reputation at this point, however, due to the scandals and rumours of incest, poisoning and the murder of her previous husband, that her new family taking any chances. Before the deal was struck, a dowry of 100,000 ducats was handed over; additionally, Lucrezia agreed to leave her son Rodrigo behind in the care of relatives. She would never see him again.

Pope Alexander died in 1503, providing some respite for Lucrezia from her family's all-consuming political machinations. When Alfonse's father died, he and Lucrezia became the Duke and Duchess

of Ferrara. She turned to patronage of the arts and religion in the later years of her life. In 1512, she learned that her son Rodrigo had died aged just twelve years old. The news was devastating for her and according to reports, drove her to seek refuge and retreat in a convent, where she withdrew from mainstream life.

Lucrezia died at the age of thirty-nine from puerperal fever following the birth of a daughter, who also died. She is buried in the convent of Corpus Domini. Her life, reputation and history continue to be debated by historians.

Chapter 28

Dona Gracia Mendes (1510–1569)

To lovers of Jewish history, she was a revelation, lifting their images of bygone Jewish womanhood off the birthing stool and into the sophisticated salons of Europe just as Michelangelo and Titian were creating their masterpieces.[1]

While little is known of her life, we do know that Dona Gracia, also known as 'La Señora', was an immensely wealthy Jewish woman who lived during the European Renaissance. Her inspirational story is one of political intrigue, religious freedom and fortune. She was a contemporary of some of the most incredible women of her day, including noted Renaissance patron Isabella d'Este (1474–1539), Catherine de Medici, Marie of the House of Habsburg (later queen of Hungary) and Mary Tudor, the daughter of King Henry VIII of England; indeed, Thomas Cromwell was aware of Dona Gracia.

She is remembered as a 'Saviour of the Jews', was arguably one of the richest women in the world at the time and spent most of her life on high alert, playing hide and seek to stay one step ahead of those who would have her life and her fortune.

It's thought that her prominent Jewish noble family were originally from Aragon, Spain, with the surname 'Nasi', Hebrew for 'prince'. The family were likely one of the 600 from Spain who had been granted, based on their wealth, permission for an indefinite stay.

Upon being thrown out of the country in 1492 by Catholic Queen Isabella and King Ferdinand, they were forcibly baptised in Portugal in around 1497. This made them 'conversos' (or, if they were accused of continuing to practice their faith in secret 'marranos' – swine – a Jew converted to Catholicism in Spain and Portugal). As such, they adopted the Christian 'de Luna' as their family name; most conversos would have two names – the secular Christian name that they were forcibly baptised with and their original, religious-given Jewish and Hebrew names connecting them to their culture, history, and ancestors.

Dona Gracia, known as Beatrice and real name 'Hannah', was born in 1510, the daughter of Alvaro and Philippa de Luna. She was baptised, again most likely in the private chapel of the family's home. The name 'de Luna' literally meant someone who came from Luna, a mountain town in Aragon, known to have deep Jewish roots. To her family and immediate circle, she was known as 'Gracia'.

She had a younger sister Brianda, another sister Giomar who died shortly after her marriage, and a brother Aries. There may have been other siblings who did not survive. We know very little about her childhood.

At the time of her birth, it was common for Jewish women to work alongside their husbands. 'In Constantinople they handled commercial transactions for Muslim women who were prohibited from doing so. Jewish women also won the right to be purveyors to the women of the Sultan's harem.'[2]

In 1528, in a big, public and very Catholic wedding, Beatrice married fellow Converso Francisco Mendes Benveniste, a hugely prosperous international gem and spice merchant in Lisbon with close connections to Portugal's King Joao III and to whom he had regularly loaned huge sums of money. (He was born around 1482 in the town of Saragossa; at the age of ten, he made the move from

Spain to Portugal with his family and was likely forcibly baptised five years later). Francisco was also her uncle; his sister was Beatrice's mother. This incestuous inter-marriage, while utterly shocking to us today, was well known at the time. No one blinked an eye at a niece marrying her own uncle – it was an accepted Jewish tradition and ensured families retained their wealth, security and traditions from one generation to the next.

They had a secret Jewish ceremony later. He died in 1535, leaving her with their 5-year-old daughter Reyna, and half of his huge fortune.

Shortly afterwards, on 23 May 1536, the Pope established a Portuguese Inquisition, based on the terrifying Spanish version. This was an absolute disaster for families like the Mendes and Nasis who, while outwardly conforming to Catholic traditions, secretly practised Judaism. If discovered, their fortunes would be confiscated, and their lives put at grave risk – facing torture and being burnt at the stake as heretics.

Beatrice, now a 26-year-old widow, promptly upped sticks, took the young Reyna (alternatively 'Ana') and her own sister Brianda (born after 1510), and fled to Antwerp (then part of Flanders) to join Diogo Mendes, Francisco's 50-year-old brother (born 1485) and business partner, who had expanded the family fortune into the banking industry.

Beatrice's business instincts and acumen were formidable; coupled with the fortune she would have brought with her; she soon became an integral part of her brother-in-law's business.

No doubt acutely aware of the near escape she'd had, Beatrice used the family money to help other Jewish Conversos escape from Portugal, ingeniously filtering their money through a secret financial network, she ran an escape route enabling them to start new lives elsewhere.

It was life-changing and life-saving work – most of the world's Jewish population at the time was settled on the Iberian Peninsula, years before the future settlements across central and Eastern Europe. The loss of so many Jewish lives to the Inquisition presented a very clear and present danger to the fate and future of the Jewish people.

The challenge to keep their Jewish heritage alive was very real. Even in Antwerp, they dared not openly display their faith. They regularly went to Mass to avert suspicion and outwardly performed Catholic ritual; if they kept the Sabbath, they had to do it circumspectly, as they would have done in avoiding forbidden foods deemed as unclean or not kosher.

It's likely that her status as a widow gave her independence, a bonus she wasn't prepared to give up. She never remarried. Her sister, however, went on to marry Diogo and when he died, he also left half his fortune to Beatrice, making her a hugely wealthy, independent Jewish woman. While his actions say much for his respect for Beatrice's business acumen, it really put the cat among the pigeons between the sisters.

Back to the Inquisition, it was made up of a group of religious fanatics, which had extended its long tentacles into Spanish-owned Antwerp, home of the Mendes family as well as many other Jewish converso. Francisco might very well have been dead and buried, but it wasn't going to stop them pursuing him or his estate, for pretending to be a Catholic while hiding his true Jewish roots.

Of course, they also wanted to get their grubby little hands on his fortune, but they hadn't reckoned with the brains of Beatrice. She 'loaned' a huge amount of cash to Emperor Charles V to keep him happy. Then of course, she had to contend with the fortune-hunters out for her daughter Ana's hand in marriage. She confronted the emperor's sister Queen Marie, regent of the Low Countries, who had commanded Ana wed an unsavoury Catholic nobleman. Dona

Gracia said she'd rather see her daughter drown than do so. It was time to flee, once again, this time to Venice.

During this time, to get her hands on some of the family fortune, Beatrice's jealous sister denounced her to the Venetian authorities as a Jew. They, of course, were hugely interested in the information, especially with such vast amounts of money at play. Betrayed by her own blood, Beatrice was placed under house arrest and her daughter, along with Brianda's daughter, were both placed in a nunnery, for the good of their 'Christian' souls. Brianda was greedy and resentful enough to make similar accusations against her sister in France; ultimately this worked against her, as the French authorities no doubt saw Brianda as part of the money chain too, and she began to be investigated.

In an article for the Jewish Publications Society of America, Cecil Roth writes that again, the family were fighting for the legal rights to their own property on the grounds of heresy, a convenient obfuscation for what was really at stake: the state wanting what they had. And to win, again:

> there had to be protestations of orthodoxy, a vast outlay of money, interminable pleadings, judicious gifts, expensive certificates of unimpeachable religious observance, constant backdoor intrigues.[3]

Supported by the Sultan of Turkey, by 1549 Beatrice was released from house arrest and reunited with her daughter; in time they moved to the Duchy of Ferrara, a state in what is now northern Italy, where they could live freely as Jews with other Conversos from Portugal.

As such, Beatrice felt secure enough to change her name to Dona Gracia Nasi, 'Gracia' the Hebrew name for Hannah (meaning 'grace') and Nasi (meaning 'prince'). From her new home, she would use her

considerable wealth and contacts to continue to rescue fellow Jews from the claws of the Inquisition and get them out of Portugal. She also paid for Hebrew books, including the Bible, to be printed in Spanish, much easier for the Conversos to use.

Let us turn to the Italian port of Ancona in 1556. It had become a haven for Jewish merchants from Portugal, Sicily, Naples, and the Levant, in part encouraged by the guarantees of protection made by a number of Popes. By 1550 it's estimated the Jewish community of Ancona numbered around 2,700. However, in 1555 Pope Paul IV revoked the Jewish privileges and brought to bear, via the Papal Bull of 12 July that year, the insistence that Jews should identify themselves by wearing a yellow badge, were prohibited from owning property, be confined to a ghetto and have their work and employment restricted to the second-hand clothing trade.

For the conversos who had settled in Ancona and been baptised as Christians, it meant they were eligible to be tried by the Inquisition. Some managed to escape, but fifty-one Jews were captured and put on trial; twenty-three Jewish merchants were tortured and burned between April and June 1555, and others were sold into slavery. The Jews were outraged, including Dona Gracia, who used her not inconsiderable influence to organise an eight-month shipping and trade boycott.

By 1552 she was settled in Galata, Constantinople where she became a leading patron of the Jewish community, establishing a yeshiva (a Jewish seminary for men), and supporting the building of synagogues, schools and hospitals. The religious and educational institutions were built to encourage her fellow Jews to return to their faith. She also continued the family business, trading goods with her own fleet of ships. Dona Gracia organised the betrothal of her daughter Ana, now Reyna Nasi, to marry her husband's nephew and business partner, Don Joseph Nasi.

Four hundred years before the establishment of the State of Israel in 1948, Dona Gracia was responsible for attempting to re-settle Jewish refugees in the Holy Land. Once again utilising her connections with the Ottoman sultan, she obtained leasing rights for land in Tiberias (part of Ottoman Syria at the time) as a refuge for Spanish and Portuguese conversos, and helped Jews return to their ancestral homeland, establishing a cultural and economic centre.

A postage stamp was centuries later issued in Israel in her honour; using a portrait from a medal minted in Ferrara around 1551. Although long believed to be that of Dona Gracia, the portrait from the medal is that of her eighteen-year-old niece Gracia, daughter of Brianda on the occasion of her marriage to Samuel Nasi. Following protracted negotiations between the Turkish sultan and the Duke of Ferrara, Samuel and Gracia were permitted to leave for Constantinople with their fortune, in 1558.

La Señora died in Istanbul in 1569. In June 2010, New York established a Dona Gracia Day, the action followed soon after by Philadelphia. An Italian white wine is also named after her, a commemorative medal was produced by the Israeli government and a museum in Tiberias is dedicated to her life and work. Descendants of the conversos she saved now live in southern Italy, Central and South America and the US.

Notes

Introduction
References:
1. https://www.museumfacts.co.uk/intriguing-facts-about-the-middle-ages/
2. https://www.historyextra.com/period/medieval/middle-ages-women-life-marriage-housewives-role-jobs-wear-clothes-husbands/
3. https://www.historylearningsite.co.uk/medieval-england/medieval-women/
4. https://www.historylearningsite.co.uk/medieval-england/medieval-women/
5. https://ajph.aphapublications.org/doi/pdf/10.2105/AJPH.82.2.288
6. https://www.medievalists.net/2010/11/women-healers-of-the-middle-ages-selected-aspects-of-their-history/
7. https://www.abdn.ac.uk/sll/disciplines/english/lion/medicine.shtml
8. Witches, Midwives, and Nurses A History of Women Healers by Barbara Ehrenreich and Deirdre English
9. https://blog.britishmuseum.org/how-to-cook-a-medieval-feast/?gclid=CjwKCAiAsYyRBhACEiwAkJFKolbarMjba7rhTxmpAQZUjsVGy9_ocb-TmycoFV4VogcSrTpC4wVe1RoCwkMQAvD_BwE

Sources:
https://www.museumofcambridge.org.uk/wise-women-traditional-cures-and-remedies/

Chapter 1: Theodora
References:
1. Stella Duffy, The Empress from the Brothel, writing for The Guardian, https://www.theguardian.com/lifeandstyle/2010/jun/10/theodora-empress-from-the-brothel

Sources:
https://www.historyhit.com/facts-about-theodora-byzantine-empress-courtesan-and-feminist/
https://www.historyrevealed.com/eras/classical/the-empress-from-the-brothel/
https://www.history.com/news/10-things-you-may-not-know-about-the-byzantine-empire
https://www.britannica.com/biography/Theodora-Byzantine-empress-died-548

Chapter 2: Æthelflæd

Sources:

https://www.historic-uk.com/HistoryUK/HistoryofEngland/Aethelflaed-Lady-of-the-Mercians/

https://blogs.bl.uk/digitisedmanuscripts/2018/02/independent-woman-æthelflaed-lady-of-the-mercians.html

Chapter 3: Lady Godiva

References:

1. https://www.historyanswers.co.uk/medieval-renaissance/lady-godiva-anglo-saxon-noblewoman-or-medieval-legend/
2. https://history.howstuffworks.com/history-vs-myth/godivas-ride1.htm

Sources:

http://sagasofshe.co.uk/lady-godiva/

https://helenafairfax.com/2015/11/17/lady-godiva-a-feminist-icon-and-inspiration/

Chapter 4: Matilda of Flanders

References:

1. Alison Weir, 'Queens of the Conquest', Vintage, 2017, p. 8
2. https://www.historic-uk.com/HistoryUK/HistoryofEngland/Matilda-of-Flanders/
3. https://rebeccastarrbrown.com/2017/04/12/the-truth-about-the-rough-wooing-of-matilda-of-flanders/
4. Alison Weir, 'Queens of the Conquest', Vintage Books, 2017
5. Alison Weir, 'Queens of the Conquest', Vintage Books, 2017, p. 20.
6. https://www.the-low-countries.com/article/matilda-of-flanders-the-first-queen-of-england
7. https://www.bbc.co.uk/news/uk-england-cambridgeshire-60403281
8. https://www.historic-uk.com/HistoryUK/HistoryofEngland/William-The-Conqueror-Exploding-Corpse/

Sources:

http://www.unofficialroyalty.com/royal-burial-sites/british-royal-burial-sites/norman-burial-sites/

https://www.the-low-countries.com/article/matilda-of-flanders-the-first-queen-of-england

https://www.historyextra.com/period/norman/1066-how-the-viking-diversion-cost-harold-his-throne/

William the Conqueror, by David C.Douglas, 'The Origins of Herleva, mother of William the Conqueror' by Elizabeth M.C.Van Houts from English Historical Review, Vol. 101 No.399 (1986)

Chapter 5: Anna Komnena

References:

1. Queens of Jerusalem, Katherine Pangonis, page 9
2. *Alexiad* 3.7.4-5 (Leib 1.124; trans. Sewter 120

3. The Writings of Medieval Women, vol. 14, translator and editor, M. Thiebaux, Garland Library of Medieval Literature, NY, 1987
4. A Medieval Woman's Companion, Susan Signe Morrison, p. 86
5. https://www.thoughtco.com/anna-comnena-facts-3529667
6. https://www.thoughtco.com/anna-comnena-facts-3529667
7. https://justhistoryposts.com/2018/01/21/royal-people-anna-komnene-historian-physician-byzantine-princess/
8. https://digitalcommons.lasalle.edu/cgi/viewcontent.cgi?article=1112&context=the_histories

Sources:
https://www.britannica.com/biography/Anna-Comnena
https://www.thoughtco.com/anna-comnena-facts-3529667

Chapter 6: Morphia/Morfia of Melitene/Melitine
References:
1. Defending the City of God, Sharan Newman, Macmillan 2014, p.21-22
2. Sharan Newman in *Defending the City of God*
3. http://ruthjohnston.com/AllThingsMedieval/?p=1663
4. Queens of Jerusalem: The Women Who Dared to Rule, Katherine Pangonis, p.15.

Sources:
https://peoplepill.com/people/morphia-of-melitene/
http://ruthjohnston.com/AllThingsMedieval/?p=1663
Queens of Jerusalem, Katherine Pangonis

Chapter 7: Heloise d'Argenteuil
References:
1. Albrecht Classen, https://www.medievalists.net/2014/02/abelard-heloises-love-story-perspective-son-astrolabe-luise-rinsers-novel-abelards-love/
2. A Medieval Woman's Companion, Susan Signe Morrison, p.113
3. https://www.medievalists.net/2014/02/abelard-heloises-love-story-perspective-son-astrolabe-luise-rinsers-novel-abelards-love/
4. https://www.encyclopedia.com/people/philosophy-and-religion/roman-catholic-and-orthodox-churches-general-biographies/heloise
5. James Burge, Heloise And Abelard: A Twelfth Century Love Story, p.14
6. https://qz.com/quartzy/1181897/what-is-sexual-harassment-consider-the-love-story-of-abelard-and-heloise/
7. https://qz.com/quartzy/1181897/what-is-sexual-harassment-consider-the-love-story-of-abelard-and-heloise/
8. https://www.encyclopedia.com/women/encyclopedias-almanacs-transcripts-and-maps/heloise-c-1100-1163
9. https://www.nytimes.com/2005/02/13/books/review/heloise-abelard-love-hurts.html

10. https://qz.com/quartzy/1181897/what-is-sexual-harassment-consider-the-love-story-of-abelard-and-heloise

Chapter 8: Melisende
References:
1. Queens of Jerusalem, Katherine Pangonis, p. 34
2. Queens of Jerusalem, Katherine Pangonis, p. 36
3. Orderic Vitalis, quoted in translation by Hans Eberhard Mayer, 'Angevins versus Normans: The New Men of King Fulk of Jerusalem', Kings and Lords in the Latin Kingdom of Jerusalem, Ashgate Publishing, 1994, p. IV-3
4. https://www.crusaderkingdoms.com/melisende.html, with its principal sources: Mayer, Hans Eberhard, 'Studies in the History of Queen Melisende of Jerusalem,' in Hans Eberhard Mayer, ed. Probleme des lateinische Koenigreichs Jerusalem, Variorum Reprints, 1983, pp 93-182.
5. https://www.crusaderkingdoms.com/melisende.html; Principal sources: Mayer, Hans Eberhard, 'Studies in the History of Queen Melisende of Jerusalem,' in Hans Eberhard Mayer, ed. Probleme des lateinische Koenigreichs Jerusalem, Variorum Reprints, 1983, pp 93-182.
6. Melisende of Jerusalem, The World of a Forgotten Crusader Queen, Margaret Tranovich, East & West Publishing, 2001, p.37
7. Willemi Tyrensis Archiepiscopi Chronicon, xviii: 27, 32 (p. 850).

Sources:
https://www.crusaderkingdoms.com/melisende.html
https://www.historyextra.com/period/medieval/melisende-jerusalem-queen-who-life-power/
https://www.bl.uk/collection-items/melisende-psalter
'Jerusalem, the Biography', Simon Sebag Montefiore, p. 229
'The Spending Power of a Crusader Queen: Melisende of Jerusalem' by Helen A. Gaudettefeatured in 'Women and Wealth in Late Medieval Europe', editors Theresa Earenfight; Palgrave Macmillan, New York

Chapter 9: Alice of Antioch
Sources:
Dan Jones, Crusaders

Chapter 12: Eleanor of Aquitaine
References:
1. Queen's Consort: England's Medieval Queens from Eleanor of Aquitaine to Elizabeth of York, Lisa Hilton, p.104
2. Ibid, p. 106
3. Queen's Consort: England's Medieval Queens from Eleanor of Aquitaine to Elizabeth of York, Lisa Hilton

Sources:
https://historytheinterestingbits.com/2017/08/12/fair-rosamund/https://www.
english-heritage.org.uk/learn/histories/women-in-history/eleanor-aquitaine/
https://www.english-heritage.org.uk/learn/histories/women-in-history/eleanor-
aquitaine/

Chapter 13: Rosamund de Clifford

References:
1. Speed quoted in *Oxforddnb.com*
2. Reference: https://historytheinterestingbits.com/2017/08/12/fair-rosamund/
3. https://elfinspell.com/HentznerModern.html
4. https://arounddate.com/great-expectationsgreat-expectations-by-charles-dickens/53/

Sources:
https://historytheinterestingbits.com/2017/08/12/fair-rosamund/

Chapter 14: Margaret of Beverley

References:
1. http://www.umilta.net/jerusalem.html
2. https://historycollection.com/12-of-the-coolest-medieval-women-of-all-time/4/
3. https://historycollection.com/12-of-the-coolest-medieval-women-of-all-time/4/
4. A Medieval Woman's Companion, Susan Signe Morrison, p.75-81.

Sources:
https://www.historyextra.com/period/medieval/six-trailblazing-medieval-women/
https://amedievalwomanscompanion.com/margaret-of-beverley/
http://www.umilta.net/jerusalem.html

Chapter 15: Sibylla of Jerusalem

References:
1. Knight Hospitaller 1306 Nicolle, D. Osprey Publishing, 2001
2. Reference: 'Jerusalem, the Biography', Simon Sebag-Montefiore, p. 246.
3. *Helena P. Schrader, PhD*, https://www.defenderofjerusalem.com/sybilla.html

Sources:
https://www.haaretz.com/archaeology/crusaders-escape-tunnel-from-saladin-found-in-israel-1.5484206

Chapter 16: Berengaria of Navarre

References:
1. Marion Meade, 'Eleanor of Aquitaine', p. 379, Phoenix Press 2001
2. Lisa Hilton, 'Queens Consort, England's Medieval Queens, Weidenfeld & Nicolson, 2008. p.125
3. Lisa Hilton, p 125 – 126

4. Lisa Hilton, p 125 – 126
5. Lisa Hilton, p. 125-126

Sources:

http://garethrussellcidevant.blogspot.com/2012/08/the-crusaders-bride-life-of-berengaria.html
https://www.thoughtco.com/berengaria-of-navarre-3529619
https://epistolae.ctl.columbia.edu/woman/79.html

Chapter 17: Licoricia of Winchester
References:
1. Bartlet, Suzanne. Skinner, Patricia. *Licoricia of Winchester: Marriage, Motherhood, and Murder in the Medieval Anglo-Jewish Community.* London: Vallentine Mitchell, 2009. Pp. xiv, 160. ISBN: 978-0-853030-8220-1
2. Lisa Hilton, p 125 – 126Rebecca Abrams, https://www.smithsonianmag.com/smart-news/meet-the-most-important-jewish-woman-in-medieval-england-180979486/

Sources:

https://jwa.org/encyclopedia/article/licoricia-of-winchester
https://www.adl.org/education/resources/glossary-terms/blood-libel
https://www.smithsonianmag.com/smart-news/meet-the-most-important-jewish-woman-in-medieval-england-180979486/
https://scholarworks.iu.edu/journals/index.php/tmr/article/view/17062
https://www.medievalists.net/2010/07/licoricia-of-winchester-marriage-motherhood-and-murder-in-the-medieval-anglo-jewish-community/
https://www.haaretz.com/jewish/.premium-1278-all-english-jews-arrested-by-crown-1.5291031
https://www.thejc.com/judaism/features/the-wealthy-widow-who-made-her-mark-in-medieval-england-1.487076

Chapter 18: Philippa of Hainault
References:
1. Source: Trotter, D.A., ed., *Walter of Stapeldon and the pre-marital inspection of Philippa of Hainault* (French Studies Bulletin, 49, pp. 1-4,1993).

Sources:

https://rebeccastarrbrown.com/2017/03/04/the-mother-of-too-many-sons-philippa-of-hainaut/
http://www.englishmonarchs.co.uk/plantagenet_35.html
https://rebeccastarrbrown.com/2017/03/04/the-mother-of-too-many-sons-philippa-of-hainaut/ https://gazette665.com/2018/05/18/10-things-you-should-know-about-queen-philippa-of-hainault/;

Chapter 19: Julian of Norwich
References:
1. Julian of Norwich: Revelations of Divine Love
2. (E A Jones, 'Anchorites and Hermits in Historical Context', in *Approaching Medieval English Anchoritic and Mystical Texts*, ed. by Dee Dyas, Valerie Edden and Roger Ellis (Cambridge: D S Brewer, 2005), pp. 3–18 (p. 12).
3. https://www.bl.uk/medieval-literature/articles/the-life-of-the-anchoress
4. https://www.bl.uk/medieval-literature/articles/womens-voices-in-the-medieval-period

Sources:
Julian of Norwich and Anchoritic Literature, Denise N. Baker
Mystics Quarterly
Vol. 19, No. 4 (December 1993), pp. 148-160 (13 pages)
Published by: Penn State University Press
https://www.theculturium.com/julian-of-norwich-revelations-of-divine-love/

Chapter 20: Alice Perrers
References:
1. https://rebeccastarrbrown.com/2017/03/04/the-mother-of-too-many-sons-philippa-of-hainaut/

Chapter 21: Katherine Swynford
References:
1. https://history.lincoln.ac.uk/2018/07/30/lincolns-scandalous-mistress/
2. Lucraft, Jeannette. "Missing from history: Jeannette Lucraft recovers the identity and reputation of the remarkable Katherine Swynford." History Today 52.5 (2002): 11+. General OneFile. Web. 9 Feb. 2015
3. https://history.lincoln.ac.uk/2018/07/30/lincolns-scandalous-mistress/
4. https://rebeccastarrbrown.com/2018/04/08/the-most-successful-mistress-katherine-swynford-duchess-of-lancaster/

Sources:
https://rebeccastarrbrown.com/2018/04/08/the-most-successful-mistress-katherine-swynford-duchess-of-lancaster/
http://www.medieval-life-and-times.info/medieval-women/katherine-swynford.htm
https://www.historytoday.com/archive/missing-history
https://royalcentral.co.uk/features/the-royal-duchess-who-went-from-mistress-to-matriarch-111134/
https://thehistoryjar.com/tag/sir-thomas-swynford/
Alison Weir, *Katherine Swynford: the Story of John of Gaunt and his Scandalous Duchess* (Vintage, 2008).

Chapter 22: Christine de Pizan
References:
1. *Christine De Pizan: Her Life and Works,* Charity Cannon Willard p.51
2. Source: THE BOOK OF THE CITY OF LADIES by Christine de Pizan. Translated by Earl Jeffrey Richards. Foreword by Marina Warner. Persea. 281 pp.

Sources:
https://amedievalwomanscompanion.com/christine-de-pizan/
A Medieval Woman's Companion, Susan Signe Morrison
https://www.open.edu/openlearn/history-the-arts/world-changing-women-christine-de-pizan
https://www.nationalgeographic.com/history/magazine/2020/03-04/single-working-mom-europe-first-professional-woman-writer/
https://departments.kings.edu/womens_history/chrisdp.html
Sunshine for Women. Feminist Foremothers 1400 to 1800. 12 April 2001.
https://www.jeanne-darc.info/contemporary-chronicles-other-testimonies/christine-de-pizan-le-ditie-de-jehanne-darc/
www.jeanne-darc.info

Chapter 23: Margery Kempe
References:
1. https://www.lrb.co.uk/the-paper/v44/n03/barbara-newman/peasants-wear-ultramarine
2. https://www.bl.uk/collection-items/the-book-of-margery-kempe
3. Evans, Ruth. 'Book of Margery Kempe, The (c.1430).' The Cambridge Guide to Women's Writing in English, edited by Lorna Sage, et al., Cambridge University Press, 1st edition, 1999. Credo Reference.
4. https://www.historic-uk.com/HistoryUK/HistoryofEngland/Mysticism-And-Madness-Of-Margery-Kempe/
5. Mary Sharratt, Revelations, 2021, HMH Books
6. https://lareviewofbooks.org/article/how-to-be-a-medieval-woman-on-mary-sharratts-revelations/
7. https://www.historyextra.com/period/medieval/the-medieval-mystics-with-a-hotline-to-god/

Sources:
https://earlybritishlit.pressbooks.com/chapter/margery-kempe-excerpts-from-the-book-of-margerykempe/#:~:text=One%20night%20while%20she%20is,life%20as%20holy%20as%20possible.
https://www.theguardian.com/books/2015/may/08/archive-find-shows-medieval-mystic-margery-kempes-autobiography-doesnt-lie
https://www.bl.uk/people/margery-kempe

Chapter 24: Joan of Arc
References:
1. http://saint-joan-of-arc.blogspot.com/2009/07/joan-of-arc-quote.html

Reference:
Joan of Arc: In Her Own Words Paperback – 1 May 1996 by Edward S. Creasy (Afterword), Willard R. Trask

Chapter 25: Isabella of Castille
References:
1. https://www.historyextra.com/period/medieval/isabella-castile-europe-greatest-queen-spain-who-was-she-what-famous-for-columbus/
2. https://www.theatlantic.com/international/archive/2019/09/spain-offers-citizenship-sephardic-jews/598258/
3. King Ferdinand and Queen Isabella, 'Agreements with Columbus of April 17 and April 30, 1492,' in J. B. Thatcher, Christopher Columbus, His Life and Work, 3 vols. (New York and London: Putnam's Sons, 1903), vol. 2, pp. 442-451.
4. https://tudortimes.co.uk/guest-articles/isabella-of-castile
5. Pulgar, Crónica de los Reyes Católicos, trans. in David A. Boruchoff, 'Historiography with License: Isabel, the Catholic Monarch, and the Kingdom of God,' Isabel la Católica, Queen of Castile: Critical Essays (New York: Palgrave Macmillan, 2003), p. 242.

Sources:
https://www.nationalgeographic.com/history/magazine/2019/03-04/queen-isabellas-rise-to-spanish-throne/
https://www.historyextra.com/period/medieval/isabella-castile-europe-greatest-queen-spain-who-was-she-what-famous-for-columbus/

Chapter 26: Anne Neville
Sources:
https://www.historyextra.com/period/medieval/anne-neville-white-queen-consort-life-facts-husbands-marriages-death-burial/
https://www.westminster-abbey.org/abbey-commemorations/royals/anne-neville-wife-of-richard-iii

Chapter 27: Lucrezia Borgia
References:
1. https://www.historyextra.com/period/renaissance/lucrezia-borgia-reputation-adulteress-pope-alexander-vi/).
2. (https://slate.com/technology/2006/04/a-history-of-poison.html)
3. https://www.ancient-origins.net/myths-legends-europe/banquet-chestnuts-0015542)

Chapter 28: Dona Gracia Mendez
Sources:
Woman who Defied Kings, The Life and Times of Dona Gracia Nasi, Andree Brooks
https://www.headstuff.org/culture/history/terrible-people-from-history/gracia-mendes-nasi-renaissance-businesswoman/
https://jwa.org/encyclopedia/article/nasi-dona-gracia
Cecil Roth, 'Dona Gracia of the House of Nasi', The Jewish Publication Society of America, 1977, page 56.